LIGHTHOUSES
OF THE
CAROLINAS

A Short History and Guide

Second Edition

Terrance Zepke

Pineapple Press, Inc.
Sarasota, Florida

Inquiries should be addressed to:
Pineapple Press, Inc.
P.O. Box 3889
Sarasota, Florida 34230
www.pineapplepress.com

Library of Congress Cataloging-in-Publication Data
Zepke, Terrance,
Lighthouses of the Carolinas : a short history and guide / Terrance Zepke. -- 2nd ed.
 p. cm.
Includes index.
Summary: "An updated guide to the lighthouses of North Carolina and South Carolina with photographs, maps, and interesting facts"-- Provided by publisher.
ISBN 978-1-56164-503-9 (pbk.)
1. Lighthouses--North Carolina. 2. Lighthouses--South Carolina. I. Title.
VK1024.N8Z46 2011
387.1'5509756--dc23
 2011020247

Second Edition
10 9 8 7 6 5 4 3 2 1

Printed in the United States of America

TABLE OF CONTENTS

Color section between pages 48 and 49.

Additional Information 167

ACKNOWLEDGMENTS

There were so many people who went out of their way to provide photographs, verify facts, point me in the right direction, and give me encouragement that I hardly know where to start. I want to be sure to thank the following folks: local historical groups, tourism bureaus, the National Park Service, conservation groups, historical museums, librarians, NC Department of Archives and History, SC Department of Archives and History, Carolinian Library, NC Travel and Tourism, USCG Historian Office, National Maritime Initiative, SC State Park Service, Outer Banks History Center, and The National Archives.

There is a list in the back of this book of all the local conservation groups that have leased lighthouses from our government. I would like to thank them for their invaluable assistance with this project and for their tireless efforts to save and protect our lighthouses. Please consider a tax-deductible donation to help them.

To all the state and local tourism officials who answered all my questions with incredible patience.

To all those folks who allowed me onto private property to see otherwise inaccessible lighthouses: ADM Corporation, Greenwood Development Company, Oak Island Coast Guard, International Pa-

per Realty Corporation, Cape Romain Wildlife Refuge, and Melrose Corporation. There are some I can't mention because they weren't supposed to give me access, but you know who you are!

To all the crazy boat captains who took me into dangerously shallow waters to get a close look at the most remote lighthouses. Thanks for wading out to help me back to the boat, Cap'n Ron!

What can I say but "you're the best" to all the NPS employees who shared little known facts and stories relating to these lighthouses.

My sincere thanks to a special group of people who helped me more than they will ever know. I apologize for not including individual names but the list would be too long and, I'm afraid, incomplete as introductions were sometimes incredibly informal. But you know who you are and how grateful I am for your time and expertise.

INTRODUCTION

Lighthouses have always been around, in one way or another. In ancient times, signal fires were lit to show ships where the shoreline was so that they didn't run aground. Later, burning coals were placed inside metal containers that were suspended on poles.

The first significant lighthouse that we know about was built in 280 BC in Alexandria, Egypt. It was named the Pharos Lighthouse because it was on the island of Pharos. This lighthouse was one of the Seven Wonders of the Ancient World. At 450 feet high (equivalent to a forty-five-story skyscraper), it would be one of the tallest lighthouses in the world if it still existed. It's incredible to think that this structure was totally hand-built—which also explains why it took twenty years to complete. Its light came from a huge fire built inside a room at the top of the tower. Slaves, supervised by priests, kept the light burning every night. Pharos Lighthouse stood for nearly 1,500 years before a massive earthquake destroyed it.

The first American lighthouse was built in 1716. It was Boston Light on Little Brewster Island at Boston, Massachusetts. It is commonly known as the Boston Harbor Light Station. The forty-foot-tall tower was

destroyed during the Revolutionary War, but another light was built in 1783. It has illuminated the shore ever since. Even though it was automated in 1998, Boston Light still has keepers in uniforms so that visitors can enjoy an authentic experience.

Since 1767, lights have existed along the Carolinas' coast to help mariners. Lightships were often used in conjunction with lighthouses wherever conditions were especially dangerous, such as at Frying Pan Shoals and Diamond Shoals.

Lifesaving stations were as important as the lighthouses and lightships that illuminated our coast. Servicemen risked their lives every time they rowed out in rough seas to help ships in distress. At one time, there were 279 lifesaving stations on the Atlantic and Pacific coasts and along the shores of the Great Lakes. They were typically built about seven miles apart. North Carolina had twenty-nine stations. Lifesaving stations were in service from the early 1870s until 1915 when the U.S. Life-Saving Service became the U.S. Coast Guard. Most of the stations were closed at that time.

Today, there are sixteen lighthouses still standing, scattered along the coast of the Carolinas. Because of radar and sonar, these beacons are no longer necessary, but when they were built, they were vital for all ships traveling our waterways. One look at a map of the Carolinas' coastline will show why these lighthouses were so important. The coast is pierced with narrow inlets, sounds, rivers, and channels that are ever-shifting, making it difficult to know where the deep water ends and where the shallows and sand bars begin.

North Carolina's Cape Fear River is the only direct deepwater access between the Atlantic Ocean and Wilmington, the state's biggest port. The route is full of channels and sand bars, beginning with the dangerous Frying Pan Shoals. That is why most of the lower coast lighthouses were built, including Bald Head Island Lighthouse and Oak Island Lighthouse.

The other North Carolina lighthouses are on the Outer Banks, a series of skinny islands stretching for roughly 175 miles. To make matters worse, the warm northbound Gulf Stream current (coming from the Caribbean) mixes with the cool southbound Labrador current (coming from Canada). This creates thick fog, unpredictable weather, strong currents, and perilous shoals, especially around the Outer Banks. This area has

been nicknamed the "Graveyard of the Atlantic" because more than 600 ships have sunk in these waters. Some argue the number is closer to 1,000. The most famous shipwreck is the USS Monitor, which sank on December 31, 1862, near Cape Hatteras.

South Carolina's coast is nearly as treacherous. The Georgetown and Cape Romain lighthouses were built to help ships maneuver the inlets and channels of Winyah Bay and the Santee River. Vessels also had to contend with the nine miles of Cape Romain Shoals.

Lighthouses come in all different sizes and shapes, depending on the location. They can be short or tall. They can be round, square, multisided, or an open framework style. Sometimes a house for the keeper was combined with the lighthouse. This was a house with a lantern room on top of the roof. Sometimes an inlet lighthouse had to be "portable" so that it could be moved to line up with a stationary light when a channel shifted. Lighthouses can be built on land or in the water. Many different materials were used to build lighthouses. It depended on the design and what was available. These materials included stone, concrete, wood, brick, steel, cast iron, metal, and tabby (a mixture of shells, lime, sand, and water).

Each lighthouse in the Carolinas enjoys a unique place in history. Cape Lookout Lighthouse became a prototype for many later lighthouses. Cape Hatteras Lighthouse is the tallest in the United States. The original Bald Head Island Lighthouse and the Morris Island Lighthouse were among the earliest constructed in our country. The Oak Island Lighthouse and Sullivan's Island Lighthouse were among the last built.

These lighthouses have survived all kinds of challenges, including war, vandalism, neglect, and Mother Nature. Erosion, hurricanes, and earthquakes have been huge problems for many of these beacons.

Our government does not have the resources to restore and maintain these beacons. Thankfully, local nonprofit groups have stepped in and helped save these historic lighthouses. There is a list of these groups in the back of this book, plus information on a few lifesaving stations that have also been saved.

I have lived most of my life in the Carolinas and still thrill at the sight of "Old Baldy" greeting me as the ferry approaches Bald Head Island or marveling at the imposing Cape Hatteras Lighthouse whenever I visit Cape Hatteras National Seashore. This book was written to share their

Old Lighthouses

When the government is no longer able or simply not interested in being responsible for a decommissioned lighthouse, they often auction them off to the highest bidder if a local nonprofit group cannot be found to assume responsibility. Some states have struggled to find caretakers for their lighthouses. Michigan, for example, has 113 lighthouses—more than any other state. They have sold many of their beacons. Granite Island Light Station in Lake Superior was sold for $86,000. North Carolina has seven government-owned lighthouses. However, most have been leased to local nonprofit groups, such as Outer Banks Conservationists and Old Baldy Foundation.

histories and give us a glimpse into the lives of heroic lifesaving personnel, vigilant lighthouse keepers, nefarious pirates, mariners, and sea captains who relied on these beacons to help them come home.

Some of these structures are in better shape than others. Not all are accessible to the public. Arguably, some are more significant and impressive than others. However, I felt it was important to include all beacons that are still in existence in the Carolinas.

ALL ABOUT LIGHTHOUSES

U.S. Lighthouse Board

In the beginning, each state was responsible for their lighthouses—they determined if there was a need, financed the construction, and took responsibility for maintaining the lighthouses. On August 7, 1789, President George Washington created legislation requiring all states to turn over their lighthouses to the federal government. The new law stated that the Secretary of the Treasury was responsible for the nation's lighthouses.

The Fifth Auditor of the Treasury, Stephen Plesanton, maintained authority for all lighthouses for more than thirty-two years. He was more concerned with fiscal responsibility than with technical advancements. For example, when the revolutionary Fresnel lens was invented in 1822, he refused to change lighting systems. Congress forced the change during the 1840s.

Congress divided America into eight districts, including two for the Great Lakes. A navy official was assigned to each district to oversee its lighthouses. By 1838, Congress relied heavily on the recommendations of the Army Corps of Engineers for everything from choosing where to put a lighthouse to how to best build and light it. In 1852, Congress approved

the U.S. Lighthouse Board comprising engineers and naval officers. They created twelve districts instead of eight. Each district had an inspector who was responsible for supervising the construction and maintenance of that district's lighthouses. It turned out to be too much work for one person, so an engineer was assigned to each district to assist the inspector. The Board was responsible for many improvements, such as building the first screwpile lighthouse, getting all beacons equipped with Fresnel lenses, and constructing the first lighthouse on the West Coast.

The Lighthouse Board also implemented new rules for keepers. They had to be able to read and write. They were required to fill out daily reports and to read written instructions from the Board regarding their duties. By 1896, keepers became civil servants.

Also, by 1896, electricity was first used in a lighthouse—the Statue of Liberty. This statue is considered an aid to navigation in addition to being a symbol of freedom. Just a few years later, the Lighthouse Board began switching to electricity in all their lighthouses. Conversion took much longer for lighthouses in remote places.

By 1910, the decision had been made to discontinue the U.S. Lighthouse Board. The U.S. Lighthouse Service (also known as the Bureau of Lighthouses) was created to take its place. The purpose for this change was to use more expert civilians and fewer military officers. Inspectors were now called Superintendents. A man named George R. Putnam was named the Commissioner of Lighthouses. He was selected by President Taft and kept the job for more than twenty-five years. He was responsible for important contributions, such as the Retirement Act for all lighthouse personnel and the introduction of radiobeacons as aids to navigation. Radiobeacons marked the beginning of an era relying more on technology, and less on a work force. Using radiobeacons ultimately resulted in the reduction of 800 employees. Other technological advancements led to automation, causing further unemployment.

By 1939, the U.S. Lighthouse Service was abolished. Its duties and responsibilities were taken over by the U.S. Coast Guard. Most employees were given the choice of becoming military personnel or remaining civilian employees. Records indicate that half the employees chose to become part of the military and the other half chose to remain civilians. During World War II, the Beach Patrol was formed to patrol our coastline

for German submarines. The Beach Patrol was a combination of Coast Guard personnel and civilian volunteers. They operated out of Coast Guard stations, lighthouses, and lifesaving stations. Radio communications were often set up at the lighthouses because the beacon towers provided good height for signaling.

There were less than sixty lighthouses with keepers by the 1960s. By 1990, only one lighthouse still had keepers, Boston Light (Massachusetts). The Fresnel lens has been replaced by a Fresnel-like lens and aerobeacons. Solar power is now used in many lighthouses.

Keepers of the Light
What was life like for a lighthouse keeper? First of all, they were usually stationed in remote places, so they had to be fairly self-sufficient. It could be a long boat ride to the mainland for provisions or a half day's journey to get to the nearest town with a store. Keepers had to climb up to the lantern room many times a day to clean the windows, polish lighting apparatus, and ready the light for that night. In the evenings, they had to light the lamp and make sure it stayed lit throughout the night. This meant carrying gallons of oil up the steps and winding the clockwork regularly so that the light worked correctly. This was a real workout. For example, Currituck Lighthouse has 214 stairs!

They had other chores too. There was painting to be done and repairs to be made. Also, the keeper had to keep a log of his activities and of all passing ships. Most keepers had gardens and livestock to help feed their families. They were not paid much money, despite the importance of their job and numerous responsibilities. Some took second jobs, even though that was against the rules.

And there were many rules. The wicks had to be trimmed every four hours. The light had to burn from dusk to sunrise. A keeper had to be able to read and write to keep logs. He had to be in good health because of the physical demands. No one under the age of eighteen or over fifty was hired, presumably because of the physical demands. Everything had to be in good condition when the inspector came—even the privy (bathroom) had to be spotless.

What did lighthouse keepers wear? By 1884, uniforms were required. Keepers were required to be in dress uniform when manning the

light. This consisted of a vest, coat, dark blue pants, and a cap. There was a uniform apron that could be worn over the dress uniform when performing small jobs. A brown suit, called a fatigue uniform, was required to be worn at all other times, such as when doing chores. These uniform requirements extended to those aboard a lightship but not to women keepers. Women were not required to wear a uniform.

Some stations had up to five keepers but some had only one keeper to do all the work. Female keepers were not usually hired, but there were 175 female keepers on record. Usually, these women took over the job when a father or husband became ill or died. Many daughters and wives were unofficial "assistant" keepers long before they were recognized professionally.

Women were officially appointed to help their husbands or fathers if the men became ill or died. On rare occasions, women were appointed on their own merit. Whatever the reason, these women took on a tough job and a big responsibility.

There are famous female keepers. Maria Andreu (Maria Mestre de los Delores) served from 1859–1862 at St. Augustine, Florida. She was the first Hispanic-American light keeper.

Abbie Burgess Grant was born in 1839. She moved to Matinicus Rock, Maine with her family. This is a very remote island, at least thirty miles to any landfall. Her father was the official keeper but he left her in charge whenever he had to go to the mainland. Once, a terrible storm erupted during her father's absence. He couldn't get back for about a month. Abbie took care of her siblings and her sick mother and kept the light going. She was an official keeper from 1867–1875. When she married Isaac Grant she moved to Whitehead Island, Maine, where she served as keeper of the Whitehead Light for fifteen years (1875–1890). She also found time to have four children! She died in 1892. *Keep the Lights Burning, Abbie* is a children's book written about the storm of 1856 and how brave, young Abbie kept the light going in her father's absence. She is one of the most famous female lighthouse keepers.

Susan Harvey served at Mahon, Delaware (1849–1859). She took over when her husband died. Despite letters on record praising her good work, she fought a political battle to keep the job for a decade. She also raised several children while working full time as a keeper.

Ida Lewis was an unofficial keeper at Lime Rock Light Station in

Rhode Island (1857–1879). Her father was sick for a long time, so she assumed his duties. He died in 1872. Ida's mother was appointed but Ida did the job. By 1879, Ida officially took over. She served until 1911. She is credited with single-handedly saving at least eighteen lives. The Lighthouse Board was so impressed with her that when she retired, they changed the name from Lime Rock to Ida Lewis Rock Light Station. The Lighthouse Service also changed the name of the lighthouse.

Katie Walker is another female keeper worth mentioning. She took over after her husband died of pneumonia in 1886. The first time she applied, the government rejected her application. She was only four feet, ten inches, and weighed just 100 pounds. They didn't think she was sturdy enough to do the job. When several men rejected the position because of the remote location, Katie's application was finally approved. She served as keeper of the Robbins Reef Light Station from 1894–1919. She retired at 73! She rescued more than fifty people.

Lighting a Lighthouse
The lighting systems changed a lot over the years. By the mid-1800s, all our lighthouses used Fresnel lenses. The Fresnel (pronounced "freh-NELL") lens was one of the greatest lighting discoveries. The lens was named after French engineer and inventor, Augustin-Jean Fresnel. He learned that by placing prisms (glass pieces) in a certain pattern around the lamps, the light power increased greatly. The prisms were held in place by a brass framework on a pedestal.

Fresnel lenses come in many sizes, called "orders." The largest is a first-order. First- through third-order was used for coastal lights. Cape Hatteras is a coastal light so it needed the brightest light—a first-order Fresnel lens. Fourth- through sixth-order lenses were used for inland (river) or harbor lights. Georgetown Lighthouse was an inland light, so it needed only a fourth-order Fresnel lens. This was later replaced with a fifth-order Fresnel lens.

The light could be fixed (steady) or flashing. To make the light flash, there were gears that turned the light. Despite technological advancements, the light still works using the same principle from the 1800s.

Many of the lights no longer have their Fresnel lenses. They were removed when the lighthouses were taken out of service.

Lighthouse Keeper Rules

By 1896, all keepers were civil servants. Since they were government employees, they had to follow these rules issued by the federal government:

1. You are to light the lamps every evening at sun-setting, and keep them continually burning, bright and clear, till sun-rising.

2. You are to be careful that the lamps, reflectors, and lanterns, are constantly kept clean, and in order; and particularly to be careful that no lamps, wood, or candles be left burning anywhere as to endanger fire.

3. In order to maintain the greatest degree of light during the night, the wicks are to be trimmed every four hours, taking care that they are exactly even on the top.

4. You are to keep an exact amount of the quantity of oil received from time to time; the number of gallons, quarts, gills, & c., consumed each night; and deliver a copy of the same to the Superintendent every three months, ending 31 March, 30 June, 30 September and 31 December, in each year; with an account of the quantity on hand at the time.

5. You are not to sell, or permit to be sold, any spirituous liquor on the premises of the United States; but will treat with civility and attention such strangers as may visit the Lighthouse under your charge, and as may conduct themselves in an orderly manner.

6. You will receive no tube-glasses, wicks, or any other article which the contractors, Messr. Morgan & Co., at New Bedford, are bound to supply, which shall not be of suitable kind; and if the oil they supply, should, on trial, prove bad, you will immediately acquaint the Superintendent therewith, in order that he may exact from them a compliance with this contract.

7. Should the contractors omit to supply the quantity of oil, wicks, tube-glasses, or other articles necessary to keep the lights in continual operation, you will give the Superintendent timely notice thereof, that he may inform the contractors and direct them to forward the requisite supplies.

8. You will not absent yourself from the Lighthouse at any time, without first obtaining the consent of the Superintendent, unless the occasion be so sudden and urgent as not to admit of an application to that officer; in which case, by leaving a suitable substitute, you may be absent for twenty-four hours.

9. All your communications intended for this office must be transmitted through the Superintendent, through whom the proper answer will be returned.

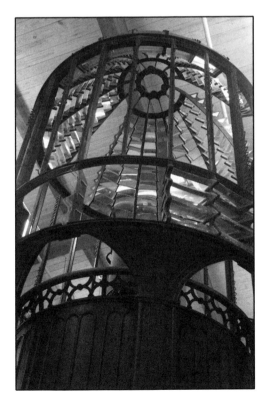

This is a first order Fresnel lens. Look closely and you can see the numerous prisms inside the protective casing.

The type of lens, and height and style of the lighthouse depended on its location. There are four types of lights: coastal, harbor, river, and range. Coastal lights were tall lighthouses, such as Cape Hatteras and Oak Island, usually equipped with a first-order Fresnel lens. Harbor lights, such as Old Baldy and Ocracoke Lighthouse, guided ships into port. River lights helped ships that traveled along our inland waterways. Roanoke River Lighthouse (recently bought by the town of Edenton from a private owner and in the process of being restored) and Roanoke Marshes Lighthouse (original destroyed, but there is a replica in Manteo, NC) were such lights. Range lights were critical for guiding ships into smaller bodies of waters—one light is stationary and the other is movable so the lights line up to reveal the exact path into the inlet, river, or harbor. North Carolina's Price Creek Lighthouse is an example of this type of light. (It is privately owned and there are no plans to move or restore the remains of this lighthouse.)

Cabbage oil?

Over the years, many fuels were used to light the lamps—whale or sperm oil, rapeseed oil, coiza oil (made from cabbage), and lard oil (made from animal fat). Kerosene was used by the late 1800s. Before oil, kerosene, or electricity, fire and candles were used. Eddystone Lighthouse in England used as many as sixty candles a night. Think how many candles they went through in a year!

TIMELINE

1716: Boston Lighthouse became the first lighthouse built in America. Located on Little Brewster Island, it was destroyed during the American Revolutionary War. It was rebuilt in 1783.

1767: Morris Island Lighthouse, SC was built.

1789: All lighthouses became property of the U.S. government. Formerly, states were responsible for constructing and maintaining their lighthouses.

1793: The first lightship was placed on the Delaware River.

1795: Bald Head Island Light Station, NC was built.

1801: Georgetown Lighthouse was built.

1802: The first Outer Banks lighthouse, Cape Hatteras Lighthouse, was constructed. It was lit the following year.

1812: The second Outer Banks lighthouse, Cape Lookout, was completed.

1812: Georgetown Lighthouse was rebuilt.

1817: Bald Head Island Light Station was rebuilt.

1818: The first lighthouses were built on the Great Lakes.

1822: There were seventy lighthouses in America.

1822: A French physicist, Augustin Fresnel, developed a sophisticated lighting system (Fresnel lens) that was eventually used in nearly every lighthouse. For more on how the Fresnel lens works, see "Lighting a Lighthouse, page 15."

1823: Ocracoke Lighthouse, NC was lit.

1827: Cape Romain Lighthouse was built.

1841: The first Fresnel lens was imported from France and used at Navesink Lighthouse, NJ.

1842: There were 256 lighthouses and thirty lightships in America.

1848: Bodie Island Lighthouse, NC was built.

1849: Price Creek and Oak Island lighthouses were built.

1850: First screwpile lighthouse was built at Brandywine Shoal, NJ.

1852: The U.S. Lighthouse Board was established. Its purpose was to decide where lighthouses needed to be built, oversee construction, and maintain the beacons.

1852: America had a total of 331 lighthouses and forty-two lightships.

1854: The first West Coast lighthouse was built on Alcatraz Island, CA.

1858: Cape Romain Lighthouse was rebuilt.

1859: Hunting Island Lighthouse, SC was built.

1859: Cape Lookout and Bodie Island lighthouses were rebuilt.

1860: The first lighthouse made of stone and built in the ocean was constructed at Minot's Ledge, MA. It took five years to complete and is considered to be an engineering feat.

1863: Hilton Head Lighthouse, SC was built.

1867: Georgetown Lighthouse was rebuilt.

1869: Hilton Head Lighthouse was rebuilt.

1870: Cape Hatteras Lighthouse was rebuilt.

1871: The first caisson lighthouse was built in the U.S., Duxbury Pier Light, MA.

1872: Bodie Island Lighthouse was rebuilt.

1873: Haig Point and Daufuskie Island lighthouses, SC were built.

1875: The last Outer Banks lighthouse, Currituck Lighthouse, was built.

1875: Hunting Island Lighthouse was rebuilt.

1876: Morris Island Lighthouse was rebuilt.

1877: Lighthouses began using kerosene to fuel the lights.

1879: Oak Island Lighthouse was rebuilt.

1886: Electricity was used to light the Statue of Liberty.

1887: Hunting Island Lighthouse was dismantled, relocated, and then relit in 1889.

1898: Many lighthouses were turned off during the Spanish-American War.

1910: The U.S. Lighthouse Board became the U.S. Lighthouse Service. For more on this, see "U.S. Lighthouse Board, page 11."

1910: There are 11,713 aids to navigation in the U.S.

1917: Many lighthouses and lightships went under the jurisdiction of the U.S. Navy and War Department during World War I.

1918: The first lightship, Diamond Shoals Lightship, was sunk by the enemy off the NC coast. The crew survived.

1928: The first radiobeacon went into operation at Cape Henry Lighthouse, VA.

1939: The U.S. Lighthouse Service was scrapped and all aids to navigation became the responsibility of the U.S. Coast Guard.

1958: Oak Island Lighthouse was rebuilt.

1962: Sullivan's Island Lighthouse, SC was built. This was one of the last lighthouses built in America.

Note: For a list of lighthouse terms and definitions, see Lighthouse Terms, page 173.

NORTH CAROLINA
LIGHTHOUSES

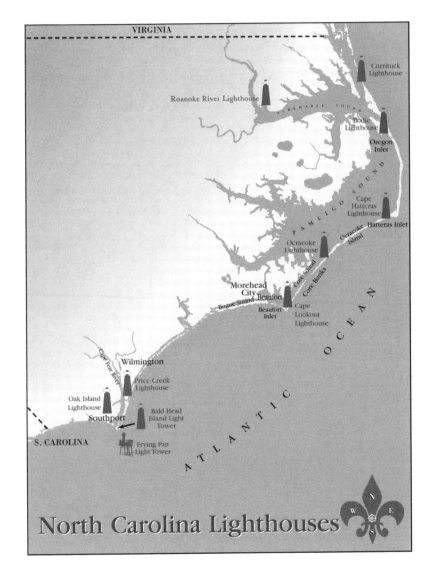

North Carolina Lighthouses

CURRITUCK LIGHTHOUSE

Closest City: Corolla, Currituck County

FAST FACTS

- It is the northernmost lighthouse in North Carolina, located just below the NC/VA state line at Whale Head Bay.

- There are 214 steps to climb to reach the top.

- This was the last beacon built on the Outer Banks.

This lighthouse was approved and Congress released the funds in the 1860s, but it was not completed until 1875 because of the Civil War. Requiring one-and-a-half years to build at a cost of $178,000, it was the last of four beacons placed at intervals from Cape Henry, Virginia to Cape Hatteras, North Carolina. Currituck Lighthouse is located thirty-four miles south of Cape Henry Lighthouse and thirty-two miles north-northwest of Bodie Island Lighthouse.

The first of many lifesaving stations was built the same year as Currituck Lighthouse. Because Currituck Sound was (and is) very shallow, the big vessels that brought bricks and other building supplies had to anchor

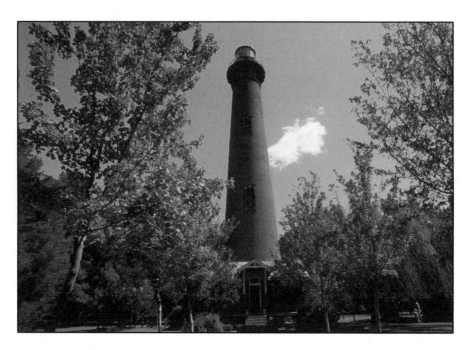

Currituck Lighthouse.

as far as eight miles out. Shallow-bottomed boats carried the materials the rest of the way. When the supplies got to the dock, they were then carried by a cart on the tramway, which ran from the wharf to the lighthouse site. Since it took more than one million red bricks to build the tower, just imagine how many boatloads and carts it took to get all of them to the construction site!

The tower sits atop a stone and piling foundation, which extends seven feet below ground. The base walls are five-feet-eight-inches thick, decreasing to three feet at the parapet. The height of focal plane lens is 158 feet and the height to the top of the roof is 162 feet.

Since the four Outer Banks lighthouses (Bodie, Currituck, Cape Hatteras, and Cape Lookout) so closely resembled one another, the Lighthouse Board had different patterns painted on each one so that mariners could tell them apart. Perhaps because it was the last beacon built, they decided not to paint this tower.

Originally, the beacon was fueled by a mineral oil lamp with five concentric wicks, the largest of which was four inches in diameter. The light

Corolla, North Carolina

The whorl of petals of a flower is called the corolla. This town name was submitted to the postmaster back in 1896. This tiny town has been called Corolla ever since. (The town pronounces it cuh-RAW-luh.) It is interesting that the population was 200 in 1900, and now, over a hundred years later, the population is still only about 500.

was fixed white with a red flash. The flash occurred every ninety seconds and had a five-second duration. The light was rotated by a clockwork mechanism beneath the lantern, which was powered by a line suspended by weights, somewhat like a grandfather clock's mechanism.

The keeper was responsible for climbing the stairs and hand-cranking the weights every two and a half hours. During World War I, three keepers worked eight-hour shifts to keep watch for enemy ships and submarines.

It is still considered a navigational aid so its light still comes on nightly. Automated in 1939, the electric light now has a flash pattern of three seconds on and seventeen seconds off, and can be seen from almost nineteen miles out to sea. The 1000-watt bulb is encased in a first-order Fresnel lens. The light comes on every evening at dusk and goes off at dawn.

The keeper's house is a Victorian "stick style" edifice. It was constructed using pre-cut parts and directions. It was shipped by barge and assembled at Currituck. It was big enough to house two keepers' families. A smaller house was moved to the site in the early 1920s when it was decided that a third keeper was needed. These houses became distressed after years of being vacant. Restoration began in the 1980s and was completed a few years later, thanks to the Outer Banks Conservationists. OBC leases all buildings (except the lighthouse) and the grounds

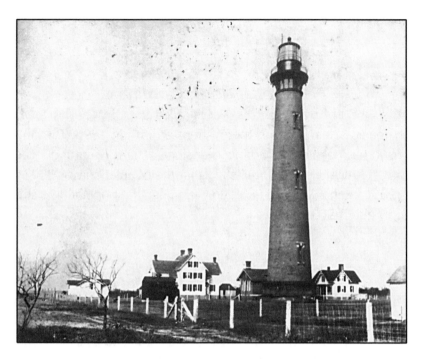

Currituck Lighthouse compound, including keepers' houses, lighthouse, and all outbuildings, circa 1893-1899.

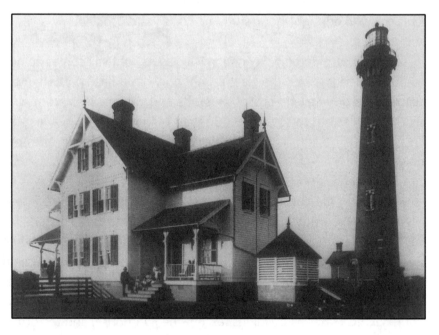

Curritick Lighthouse Keeper's House, circa 1889. Look closely and you can see the keepers' families posing on the porches and steps.

Before and after restoration photos of the Keepers' duplex.

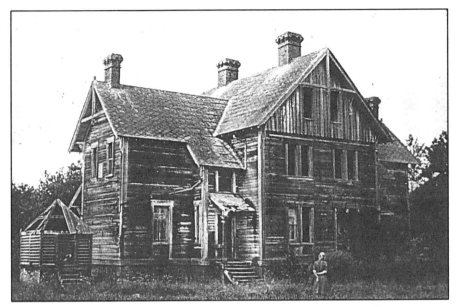

(before)

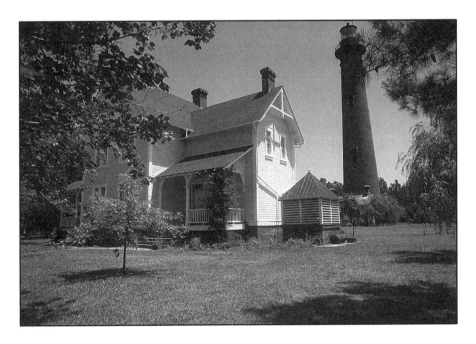

(after)

During World War II, the Coast Guard patrolled the beach with dogs. There was a dog training station located beside the lighthouse. All houses had blackout shades and could have only one light on per family. Darkness was essential so that German subs could not see our ships.

from the State of North Carolina. The Lighthouse was transferred from the U.S. Coast Guard to the National Park Service in 2003. Today, the smaller house is also a museum and gift shop.

One of the duties of the keeper of Currituck Lighthouse was to dispose of all the geese and ducks that crashed into the windows of the lantern room. There was a net across the top of the lighthouse to catch the birds. Ever practical, the keepers ate the waterfowl, giving any surplus to neighbors.

Other Points of Interest

Currituck National Wildlife Refuge has over 1,800 acres full of wildlife such as blue herons and wild ponies. It is open to the public during daylight. 252-429-3100. www.fws.gov/currituck

Historic Corolla Village includes Corolla Chapel, Corolla Schoolhouse, and the Kill Devil Hills Lifesaving Station (moved here in 1986, it is home to a business but lifesaving memorabilia can be found next door at Twiddy & Co.). www.corollaguide.com

Outer Banks Center for Wildlife Education features waterfowl, ecology, and wildlife. It is located in a building behind the Whalehead Club. It is open to the public seasonally. 252-453-0221. www.ncwildlife.org

Whalehead Club is a 20,000-square-foot mansion built in 1925 by wealthy railroad industrialist Edward Collins Knight. When his wife was refused admission to the all-male hunt club, he bought the property and had the club torn down. In its place, he built a thirty-five room $385,000

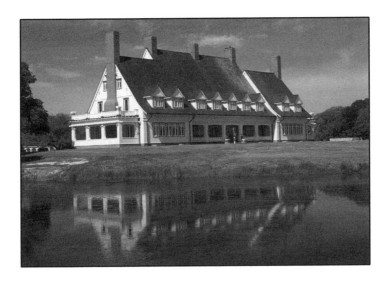

Whalehead Club.

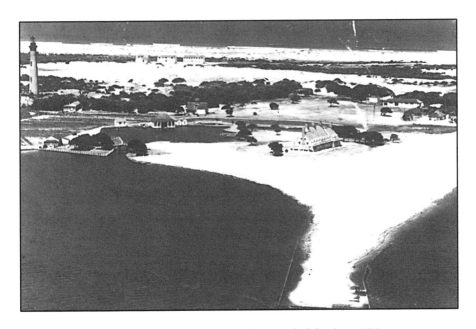

Aerial view of Currituck Lighthouse and the Whalehead Club, circa 1950s.

Looking for Adventure

The Outer Banks is the place for adventurous souls. Visitors can choose from a myriad of activities, such as off-road exploring, sightseeing cruises, fishing, eco-excursions, and more. Here's a partial list of companies and options:

Island Cruisers rents 4x4 vehicles. A four-wheel-drive vehicle is the only way to access the northern beaches. 252-987-2097. www.islandcruisersinc.com

Wild Horse Adventure Tours allows you to see the descendents of Spanish mustangs. The wild horses are beautiful and so is the remote area you will visit. 252-489-2020. www.wildhorsetour.com

Nags Head Dolphin Watch offers eco-outings. 252-449-8999. www.nagsheaddolphinwatch.com

Pirate Adventures of the Outer Banks. 252-473-1475. www.piratesobx.com

Outer Banks Air Charters for aerial tours. 252-256-2322. www.outerbanksaircharters.com

For more information visit www.corollaguide.com

mansion and started his own hunt club. It has many incredible amenities, including fifteen bedrooms, copper roof shingles, cork floors, mahogany doors, Tiffany lighting fixtures, an elevator, and a swimming pool (the first on the Outer Banks). There was a caretaker's house and boathouse too. Over the years, the property has been used as a Coast Guard training center, a private school for boys, and a rocket fuel testing facility. It is open to the public seasonally. 252-453-9040. www.whaleheadclub.com

Visitor Information
This lighthouse is open to the public! It has been since 1991, thanks to the Outer Banks Conservationists. For hours of operation call 252-453-4939 or 252-453-8152. www.currituckbeachlight.com

Getting There
Coming from the north, visitors will take US 168/VA 168 to US 158. This is a toll road. If coming from the south, it is ten miles from Kitty Hawk to the Currituck County border, and then eleven miles to where the road ends at Corolla. The first mile marker (MM) or milepost (MP) is close to the Kitty Hawk Aycock Brown Welcome Center. Most locals call U.S. 158 "the Bypass" and NC 12 "Beach Road." The lighthouse is twenty miles from the junction of US 158 (the Bypass) and NC 12 (Beach Road).

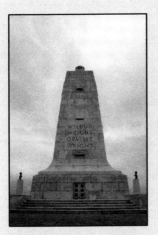

Another Type of Light
The Wright Brothers flew the first airplane at Kitty Hawk on December 17, 1903. This made North Carolina the "First in Flight" state. This monument was built in 1932. The light on top of the sixty-one-foot-high monument can be seen six miles away. 252-441-7430. www.nps.gov/wrbr

Distance to Corolla from
Chesapeake (city), VA is 90 miles
Chesapeake (Northampton Co.), VA is 133 miles
Raleigh, NC is 229 miles
Trenton, NJ is 392 miles

Visiting These Lighthouses

It looks like a little stretch of land on a map but it's 95 miles from Corolla (Currituck Lighthouse) to Buxton (Cape Hatteras Lighthouse) on a two-lane highway. During the busy summer tourist season, the trip can take up to three hours! The closest lighthouse to Currituck is Bodie Island Lighthouse. It's 37 miles south. If you're interested in seeing all the Outer Banks lighthouses, it is best to allow a few days. A whole day should be set aside to visit Cape Hatteras Lighthouse and Ocracoke Lighthouse. It's an 11-mile drive from Cape Hatteras Lighthouse to the Ocracoke ferry terminal and then a forty-minute ferry ride to Ocracoke Island. Once on Ocracoke, be advised that it is a 14-mile drive from the ferry terminal into Ocracoke Village, which includes the lighthouse.

Another day should be allotted to drive down the coast to the Cape Fear area where Old Baldy and Oak Island lighthouses are located. A private ferry takes visitors over to Cape Lookout from Harkers Island. Since this is time-consuming, it is advised to do it on a different day. You may want to take the rest of the day to see more of the Cape Lookout National Seashore. The Roanoke River Lighthouse is in Edenton, which is 66 miles from Manteo. While the lighthouse is long gone, there is now a replica of the Roanoke Marshes Lighthouse on the waterfront in Manteo.

Visitors will notice that businesses and attractions will say they are located at MM8 or MM25 or something like that. Green mile marker signs have been placed every half mile along NC 12 at the Outer Banks. Be sure to note your starting location. For example, Kitty Hawk is Milepost 1.

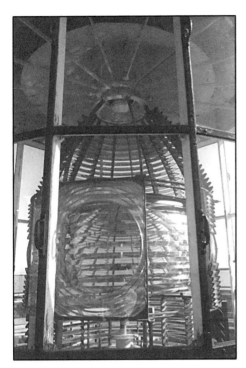

Currituck's first-order Fresnel lens.

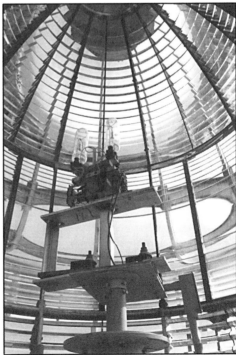

Currituck's lens and lamp changer.

BODIE ISLAND LIGHTHOUSE

Closest city: Nags Head, Dare County

FAST FACTS

- Legend has it that the island got its name because of the many bodies found around it, washed up from shipwrecks.
- The first keeper was paid $400 a year.
- Bodie Island is no longer an island. The beach now joins Nags Head.

This lighthouse serves an isolated stretch thirty-five miles north of Cape Hatteras. Bodie Island is now a peninsula attached to Nags Head, Kitty Hawk, and Virginia Beach.

The brick sentinel we see today, four miles north of Oregon Inlet, is actually the third Bodie Island Lighthouse. The first one sat on fifteen acres of land the government bought for $150 in 1846. Two years later, the beacon was lit. It stood fifty-four-feet tall and had a five-room keeper's house, cistern, and two outbuildings.

Located south of Oregon Inlet, the lighthouse was supposed to have

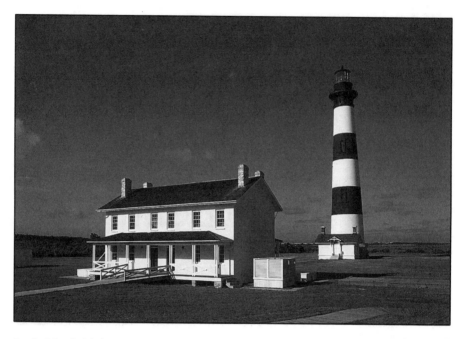

Bodie Island Lighthouse and Keeper's House.

a visibility of twelve miles. Despite numerous modifications, the light never worked properly.

A replacement lighthouse was built less than eleven years later. It was eighty-feet tall with a third-order Fresnel lens, which flashed every ninety seconds and could be seen fifteen miles out to sea. It was blown up by retreating Confederates during the Civil War.

The third and final Bodie Island Lighthouse was constructed in 1872 at a cost of $140,000, including keeper's house and outbuildings. The 150-foot beacon had a fixed light illuminated by a vapor lamp. The light became automated in the 1950s. The first-order Fresnel lens remains.

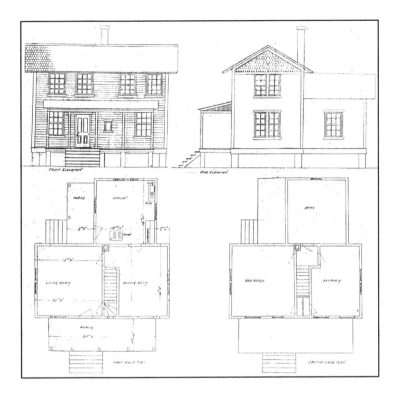

Photocopy of diagram of Bodie Island Keepers' duplex, circa 1872.

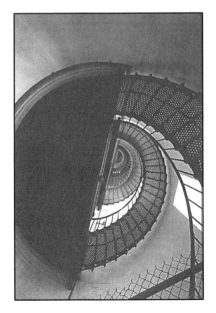

Interior stairwell of Bodie Island Lighthouse, no date.

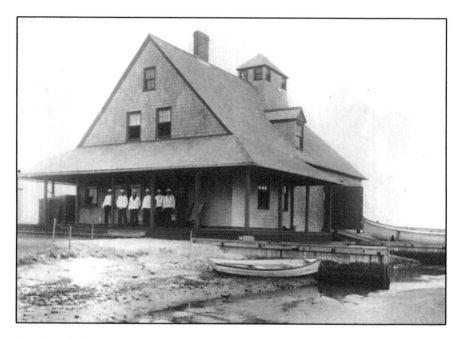

Lifesaving Station on Outer Banks, circa 1900.

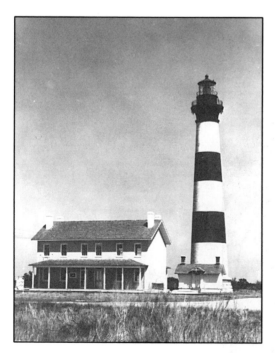

Bodie Island Lighthouse, circa 1960s.

More than 7 million visitors flock to the Outer Banks every year. Most visit at least one of these lighthouses while there: Currituck, Bodie, Cape Lookout, Cape Hatteras, and Ocracoke. The Outer Banks is a cluster of islands comprising narrow ribbons of sand connected to the mainland by private boats, state-operated ferries, and bridges.

Most sources list Cape Lookout as an Outer Banks lighthouse because of its proximity to the others but Cape Lookout is actually part of the Crystal Coast and is in Carteret County. The three counties that comprise the Outer Banks are Currituck, Dare, and Hyde.

Other Points of Interest

Cape Hatteras National Seashore is a 30,000-acre preserve full of beaches and marshes. Most of Hatteras, Ocracoke, and Bodie Islands are part of the seashore, which was America's first designated National Seashore. It is located six miles south of the US 158 and US 64 intersection, west of NC 12. 252-995-4474. www.nps.gov/caha/capehatteras.htm

Ft. Raleigh National Historic Site includes the remains of the Lost Colony fort. The site is located three miles north of Manteo on Roanoke Island. 252-473-5772. www.nps.gove/fora

Jockey's Ridge is the tallest dune on the eastern seaboard, about one hundred feet high. Hang gliders come from all over to tackle Jockey's Ridge. If you're interested in hang-gliding or flying a kite at Jockeys Ridge, check out Kitty Hawk Kites at 877-359-8447 or www.kittyhawk.com. The ridge is located at US 158, MP 12, Nags Head. 252-441-7132. www.jockeysridgestatepark.com

Lost Colony is America's oldest outdoor drama. It theorizes what happened to the first colony of settlers. This spectacular show is staged at The Waterside Theatre, 1 Collins Ct, Roanoke Island. 252-473-3414. www.thelostcolony.org

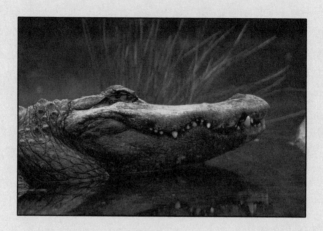

The Outer Banks for Nature Lovers

The Outer Banks is a paradise for nature lovers. There are a dozen refuges and parks, including Pea Island Wildlife Refuge, Nags Head Woods Ecological Preserve, and Lake Mattamuskeet National Wildlife Refuge. Arguably, the best bird watching is in Pea Island National Wildlife Refuge, on the north end of Hatteras Island. Observation platforms can be found throughout the refuge. Many of the animals in these designated areas are endangered. Please be respectful that there are nesting turtles and migrating birds seasonally. These are protected species. You can be prosecuted for disturbing a turtle nest or harming these animals in any way. You should also remember that there are snakes and alligators! Camping is only allowed in designated areas.

There are several companies that offer nature outings (kayaking, canoeing, and kids' camps). One is Coastal Explorations. 252-453-9872. www.coastalexplorations.com

Roanoke Marshes Lighthouse

Roanoke Marshes Lighthouse is a replica of the 1857 screwpile lighthouse that sat on the south end of the Croatan Sound. The combination keeper's house and lighthouse was an important river light. Cap'n Unaka Jennette was one of the keepers of this light. He also served for many years as the principal keeper at Cape Hatteras Lighthouse. Efforts to salvage the lighthouse were unsuccessful, so the remains are somewhere in Croatan Sound. The replica of this important river light can be found at the end of the pier on Roanoke Island on the Manteo waterfront (252-475-1750). It is equipped with a fourth-order Fresnel lens and has exhibits about the lighthouse and area history.

North Carolina river lights usually had about 1,000 square feet of living space in a one- or two-story house with a light on top. An assistant keeper and his family, if he had one, sometimes shared this space. The lighthouse sat about ten to fifteen feet above the water, secured on five steel pilings. In addition to the lighting system, there was always a fog bell. All river lights were taken out of service by the Coast Guard in 1955.

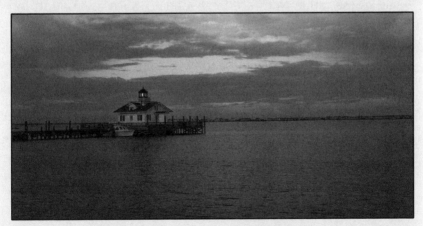

North Carolina Aquarium on Roanoke Island is a more than 68,000-square-foot facility, including an 180,000-gallon ocean tank center. 374 Airport Road, Roanoke Island. 252-473-3494. www.ncaquariums.com

North Carolina Maritime Museum has many exhibits chronicling this area's maritime history. 106 Fernando Street, Roanoke Island. 252-475-1500. www.ncmaritimemuseums.com

Outer Banks History Center is a regional archives and research library, as well as gallery. It is located in the Roanoke Island Festival Park on the Manteo waterfront. 252-473-2655. www.obhistorycenter.net

Accommodations

There are several motels and a few inns for visitors to choose from. There are several mom-and-pop and chain hotels and motels. These range from economy lodging, such as Comfort Inn Hatteras (252-995-6100 or www.outerbankscomfortinn.com), to the luxurious, such as The Sanderling Resort & Spa in Duck, NC (800-701-4111 or www.thesanderling.com).

There are also approximately 12,000 rental houses on the Outer Banks. These properties are very popular with visitors. The houses vary in size from small to mansion. Some have more than twenty bedrooms! Every amenity can be found from elevators to home theaters. One of the biggest rental companies is Twiddy & Company, 800-489-4339 or www.twiddy.com. Contact the tourism bureau for a complete list of options.

What You Should Know Before You Go

The Northern Beaches of the Outer Banks include Duck, Southern Shores, Kitty Hawk, Kill Devil Hills, and Nags Head. This is where the Wright Brothers National Memorial, **Currituck Lighthouse**, Jockey's Ridge State Park, and most restaurants, shops, and lodging can be found.

Roanoke Island and the Mainland consist of East Lake, Manteo, Wanchese Manns Harbor, and Stumpy Point. There is a lot to see and do here including Fort Raleigh National Historic Site, Elizabethan Gardens, Roanoke Island Festival Park, **Roanoke Marshes Lighthouse**, and the North Carolina Aquarium.

Hatteras Island is made up of several communities: Rodanthe, Waves, Salvo, Avon, Buxton, Frisco, and Hatteras Village. Cape Hatteras National Seashore, **Cape Hatteras Lighthouse, Bodie Island Lighthouse** (on the northern border of the seashore), Chicamacomico Lifesaving Station, Graveyard of the Atlantic Museum, Frisco Native American Museum and Natural History Center, U.S. Weather Bureau Station (Hatteras Villages), and Pea Island National Wildlife Refuge are all located here.

Ocracoke Island is a short ferry ride from Hatteras Island. The Ocracoke ponies, **Ocracoke Lighthouse**, and the exploration of historic Ocracoke Village make this a worthwhile trip.

Distance to Nags Head from

Nashville, TN is 735 miles

Columbia, SC is 397 miles

Washington, DC is 278 miles

What's in a Name?

Kill Devil Hills was reportedly named when locals smelled something bad—rum barrels had busted open from a shipwreck. They said the foul odor "would kill the devil." Nags Head got its name when locals reputedly tied lanterns around the necks of old nags and marched them up and down the beach. The idea was that mariners would mistake the lights for safety and head toward them. They would run aground and the ships would be plundered. Many houses were built using timbers from some of these shipwrecks. And don't forget that Bodie Island supposedly got its name because so many bodies washed ashore from shipwrecks.

Roanoke Island Festival Park includes a museum, an art gallery, a gift shop, and a replica Elizabeth II. 1 Festival Park, Roanoke Island. 252-475-1500. www.roanokeisland.com

Roanoke Island Maritime Museum educates the public about maritime history and boat building. 1 Festival Park, Roanoke Island. 252-475-1750. www.obxmaritime.org

Visitor Information
The base of this lighthouse is open to the public on certain weekdays during the summer. There is a museum and gift shop in the former keeper's house. (252) 441-5711. www.nps.gov/caha

Getting There
The lighthouse is between Nags Head and the Oregon Inlet. It is located eight miles south of US 158 and US 64 intersection, west of NC 12.

OUTER BANKS AVERAGE
MONTHLY TEMPERATURES

	HIGH	LOW
January	51	36
February	54	37
March	60	43
April	69	51
May	76	60
June	83	68
July	86	62
August	85	72
September	81	67
October	71	57
November	63	48
December	55	40

Note: Hurricane season is June 1–November 30.

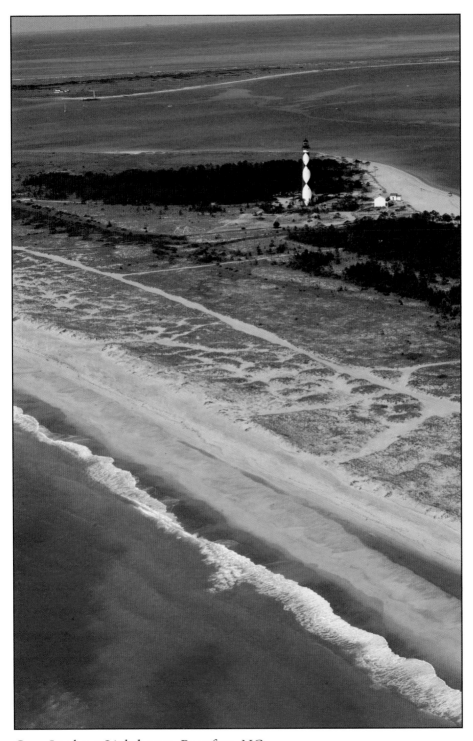

Cape Lookout Lighthouse, Beaufort, NC

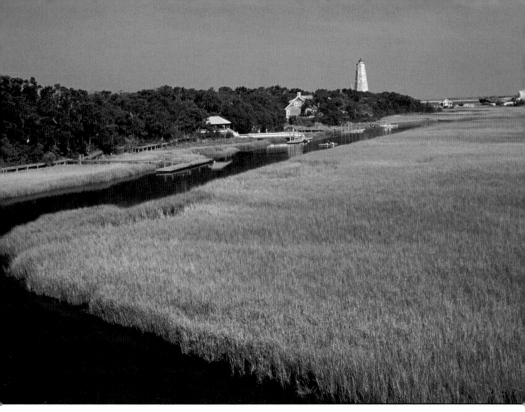

Bald Head Island Lighthouse, Southport, NC

Bald Head Island Lighthouse

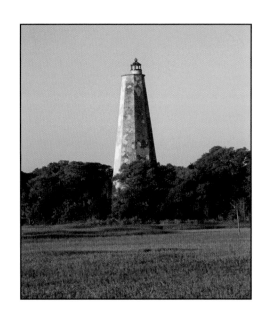

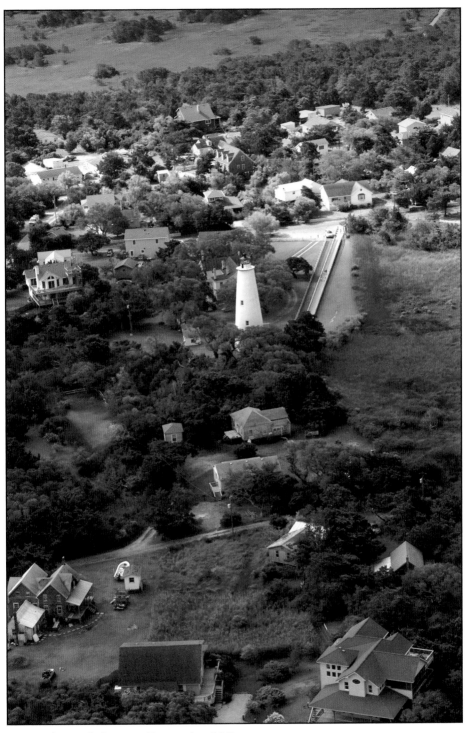

Ocracoke Lighthouse, Ocracoke, NC

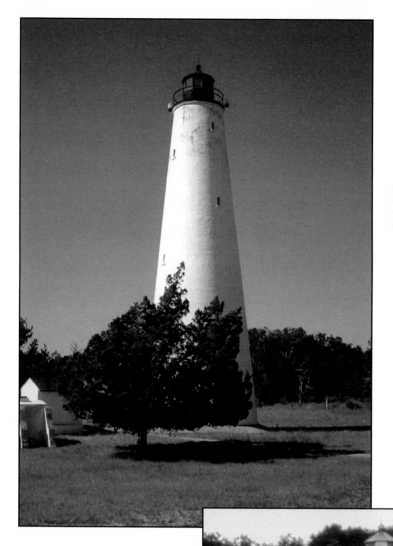

Georgetown
Lighthouse,
Georgetown, SC

Haig Point
Lighthouse, Hilton
Head, SC

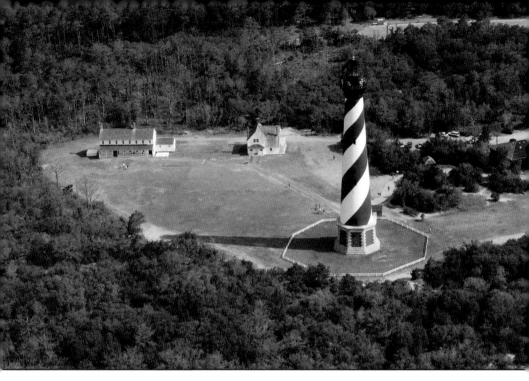

Cape Hatteras Lighthouse, Buxton, NC

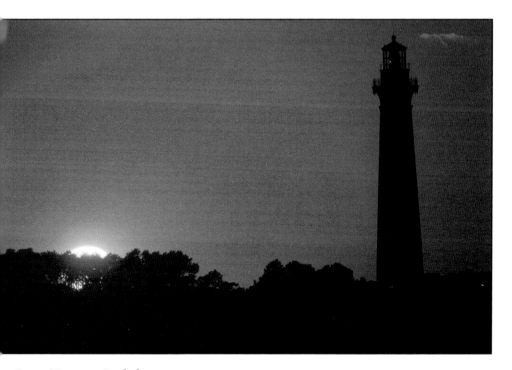

Cape Hatteras Lighthouse

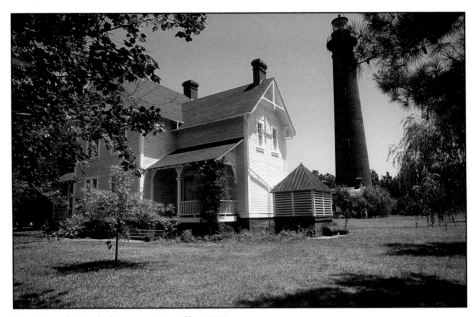

Currituck Lighthouse, Corolla, NC

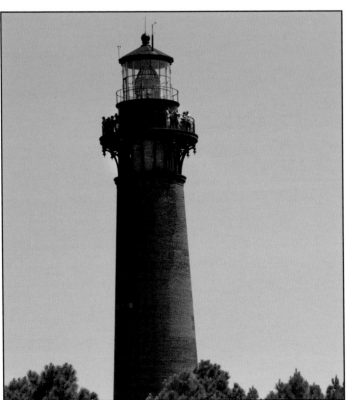

Currituck
Lighthouse

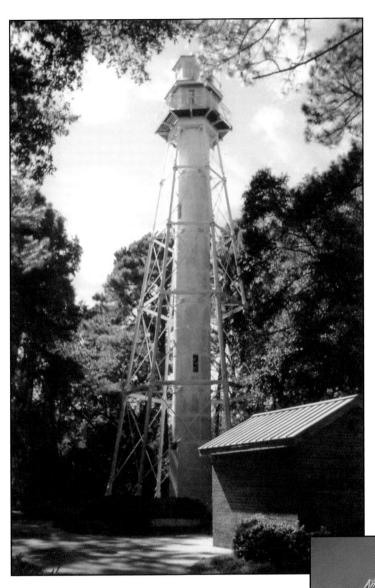

Hilton Head
Lighthouse,
Beaufort, NC

Hilton Head Lighthouse

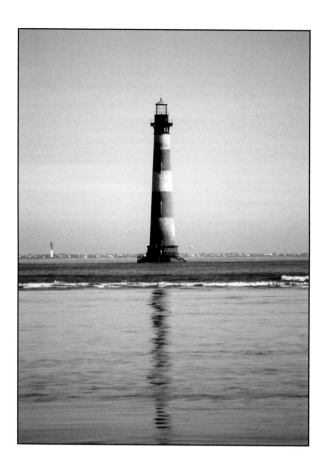

Morris Island
Lighthouse,
Folly Beach, SC

Bodie Island
Lighthouse,
Nags Head,
NC

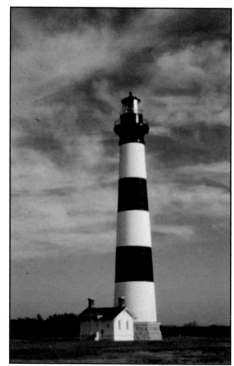

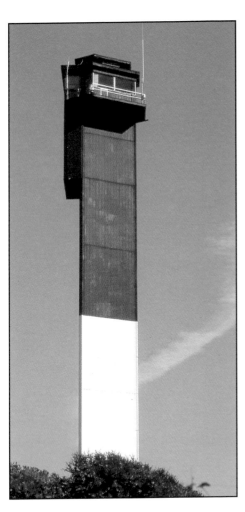

Sullivan's Island
Lighthouse, Sullivan's Island, SC

Sullivan's Island Former
Keepers House

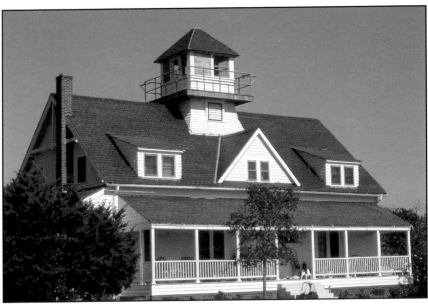

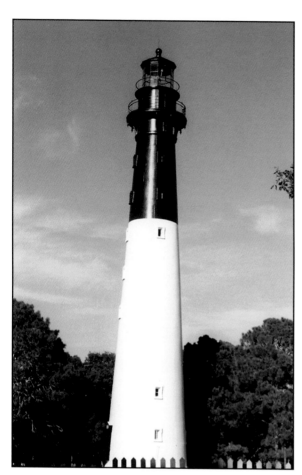

Hunting Island
Lighthouse, Beaufort, SC

Cape Romain
Lighthouses,
McClellanville, SC

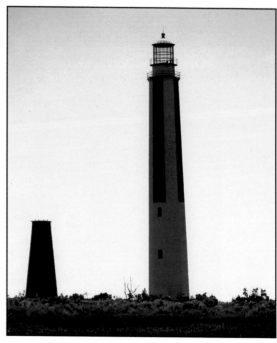

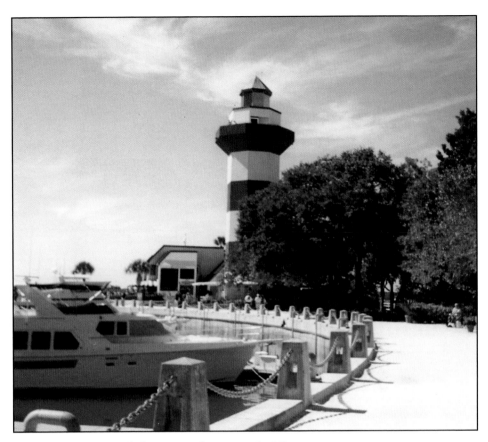

Harbour Town Lighthouse, Hilton Head, SC

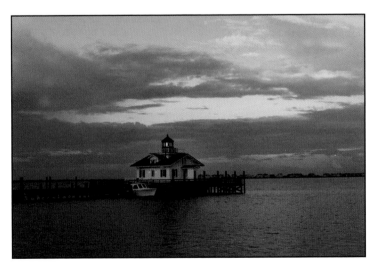

Roanoke
Marshes
Lighthouse,
Manteo, NC

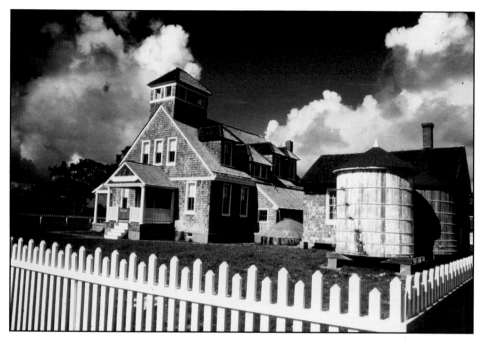

Chicamacomico Lifesaving Station, Rodanthe, NC

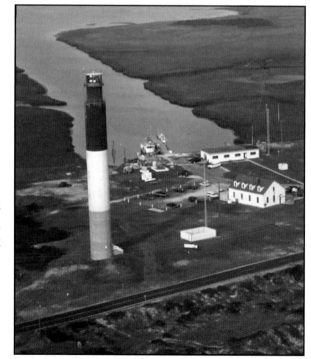

Oak Island
Lighthouse,
Caswell, NC

Errata Sheet for Lighthouses of the Carolinas, 2ⁿᵈ Edition by Terrance Zepke

ISBN 978-1-56164-503-9

These corrections apply to photographs in the color insert. Some of the captions give incorrect locations for the lighthouses.

Cape Lookout Lighthouse is at Cape Lookout National Seashore, NC.

Bald Head Island Lighthouse is on Bald Head Island, NC.

Georgetown Lighthouse is on North Island, SC.

Haig Point Lighthouse is on Daufuskie Island, SC.

Hilton Head Lighthouse is on Hilton Head Island, SC.

Hunting Island Lighthouse is on Hunting Island, SC.

Cape Romain Lighthouses are on Lighthouse Island, SC.

ROANOKE RIVER LIGHTHOUSE

Closest city: Edenton, Washington County

FAST FACTS

- This is the most recent lighthouse to be rescued and restored in North Carolina.

- A private citizen lived in the lighthouse for over fifty years.

- $225,000 was paid by the Edenton Historical Commission in 2007 for the Roanoke River Lighthouse.

Constructed in 1887, this was the second lighthouse at the mouth of the Roanoke River. It is unclear exactly when the original lighthouse was first lit, although the Outer Banks Lighthouse Society cites the date as 1867. It caught fire and was destroyed. It was rebuilt in 1885 and again in 1887 after it was knocked off its support pilings by ice. This lighthouse was in use until 1941. After it was decommissioned, it was bought by a private citizen in 1955. He took it off its screw-pile base, floated it down to Edenton on a barge, and used it as a private residence.

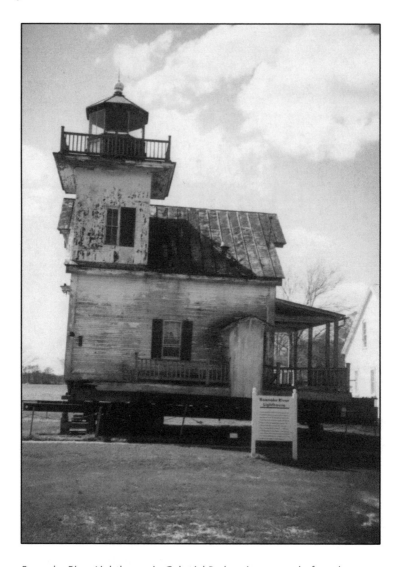

Roanoke River Lighthouse in Colonial Park as it appears before the restoration process begins.

Mr. Emmett Wiggins lived in the old lighthouse for fifty years. When he died in 1995, the structure sat abandoned for more than a decade. Repeated efforts to save the lighthouse failed until 2007 when it was finally sold to the Edenton Historical Commission for $225,000. Another $75,000 was spent to move the light to the town's waterfront park. Waff Contracting and Worth H. Hare & Son House Movers Inc. were hired to

There is a reproduction of the second Roanoke River Lighthouse (1886) and a Maritime Museum in Plymouth, NC. Take Hwy. 64 to Water Street in downtown Plymouth. The museum is across the street from the lighthouse replica. 252-217-2204. www.roanokeriverlighthouse.org

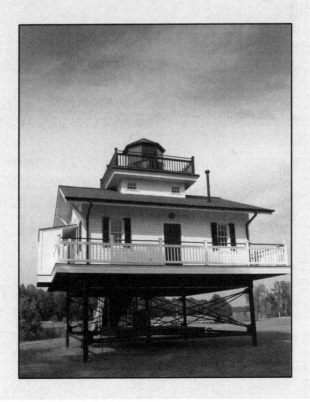

Former keeper Wayland Baum, 92, shared some interesting information in *Lighthouse News*, 1996. He was a substitute keeper at several North Carolina lighthouses. He said that the lamp parts and filling cans were made of brass and had to be polished often. There were two kinds of polish: one was a paste used when something was very dingy and the other was "Sal Soda," scrubbing powder used when a light polish was all that was required. To clean the lamp and glass, he used newspapers balled up until they were nice and soft. There were three men stationed at every river light with two on duty at all times. Families were not supposed to stay at the lighthouse, so when they saw the inspector's flag flying on his boat on route to the lighthouse, the family hid in a closet. Baum suspected the inspector knew but didn't say anything.

do the job. They used a barge with a crane and a tractor-trailer truck to move it into place.

When it was operational, it housed a fourth-order Fresnel lens. When renovations are done, the 1888 lens, made by E. Barbier and Co. of Paris, will be returned to the lighthouse. The lens is owned by the Town of Edenton and weighs more than 300 pounds.

At one time, there were twenty river lights along the North Carolina inland waterways. This is the only one of those many lights that still exists. Edenton hopes to build a maritime center near the lighthouse to draw tourists.

Other Points of Interest
There are many historically significant buildings in Edenton, such as the Barker House, Cupola House, and the Iredell House. Go to www.visit-edenton.com or the visitor center for more information.

Visitor Information
When renovations are done, the lighthouse will be open to the public. However, it will be sometime in the future before that happens, depending on funding. In the meantime, visitors can see the outside of the lighthouse by going to Colonial Park, waterfront Edenton. 252-482-7800. Visitors can also go to www.visitedenton.com and click on the lighthouse webcam for live viewing. For more information or to take a guided tour of the town, visit the Historic Edenton State Historic Site Visitor Center on Broad Street. 252-482-2637.

Getting There
If you're coming from Norfolk, Virginia (airport), take 17 South and Edenton is thirty miles south of Elizabeth City. If you're coming from Raleigh (airport), it is two hours. Take US 64 East to Williamston and then take Hwy 17 north for thirty miles.

CAPE HATTERAS LIGHTHOUSE

Closest city: Buxton, Dare County

FAST FACTS

- Cape Hatteras Lighthouse is located north of Cape Hatteras Point.
- Visitors must climb 257 steps to reach the top of the lighthouse.
- This is the tallest lighthouse in America.

Formerly located on the edge of a narrow ribbon of sand, Cape Hatteras Lighthouse is both a monument to the engineering prowess of mankind and a lesson in the futility of battling the sea.

Since the 1800s, a lighthouse at Cape Hatteras has marked the eastern tip of North Carolina's Outer Banks near Diamond Shoals, the formidable twelve-mile sandbar that lies just offshore. To help mariners avoid this dangerous sandbar, a lighthouse would have to shine far beyond these shoals.

The first Cape Hatteras Lighthouse was lit in 1803. The original lighting system was eighteen oil lamps with fourteen-inch reflectors, and the light could be seen twelve miles out to sea. But this was not enough to

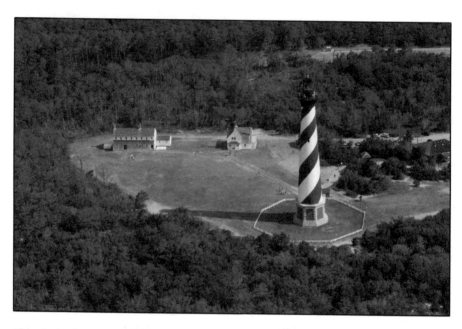

This photo shows an aerial view of Cape Hatteras Lighthouse after it was moved almost 3,000 feet inland.

Sketch of original Cape Hatteras Lighthouse after it was painted and otherwise altered, circa 1862.

Cap'n Jennette was keeper of this lighthouse from 1919–1936. He raised seven children during his service at Cape Hatteras Lighthouse. His son, Rany, even got married at Cape Hatteras Lighthouse.

By 1948, it was decided that Cape Hatteras Lighthouse still had an important role to play. The problematic erosion had reversed. The steel replacement tower was dismantled and Cape Hatteras Lighthouse was relit.

Sadly, by the mid-1980s, erosion seriously threatened this beacon once again. Much was done to stop it, including the placement of three-ton sand bags on the beach in front of the tower. Ultimately, it was decided that moving the lighthouse was the best way to protect it.

Funding requirements delayed the move; about $10–12 million was needed. Congress finally allotted the money and in 1999 the move began. The moving contract was awarded to The International Chimney Corporation of Buffalo, New York. Another company, Expert House Movers, spent nearly one year getting the lighthouse ready for the big move.

The 3,000-ton structure was moved 2,900 feet west-southwest

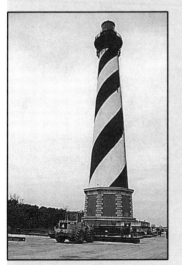

to its new spot, about 1,600 feet from the shoreline (on the other side of NC 12). This was the first time that a lighthouse of this size had been moved. In its new location the current optic is a DCB-24.

Cape Hatteras Lighthouse is on the National Register of Historic Places, is a National Historic Landmark, and a National Historic Civil Engineering Landmark. Roughly 200,000 tourists come to Cape Hatteras each year to visit this spectacular lighthouse.

safeguard ships from Diamond Shoals. Between 1845 and 1854, numerous repairs were made in an effort to correct the shortcomings but the light was still insufficient.

During the Civil War, the lighthouse was used as a lookout post. Confederates removed the lighting system before retreating so that Union soldiers could not use the lighthouse.

After the Civil War, a second Cape Hatteras Lighthouse was built to replace the first one. The new tower was to be a whopping 198 feet tall, comparable to a skyscraper. The foundation was critical to the survival of this lighthouse. The engineer chose durable pine timbers as the base. Next, a series of granite slabs were placed on top of one another, like steps. The last of these was put above ground level, and the tower built on top. The twenty-four foot by forty-six foot and six-inch octagonal base is made of brick and granite.

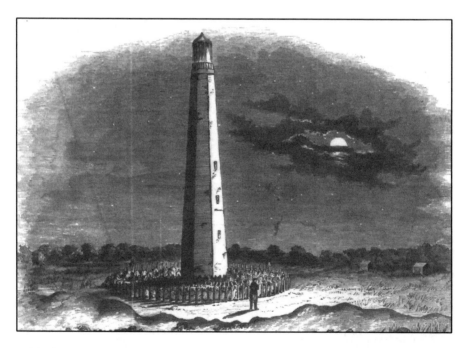

Original Cape Hatteras Lighthouse, 1861.

Construction on the $150,000 tower began in 1868, and despite the loss of some construction materials and an outbreak of malaria among the crew, the lighthouse was completed in 1870. The lighthouse, which required 1.25 million bricks to complete, was officially lit on December 18, 1870. The original lighting system required the keeper to wind weights suspended on heavy cables to rotate the thousand-prism first-order Fresnel lens. The original lighthouse was demolished when the new one was built, although the foundation remained until the 1970s when it was swept out to sea.

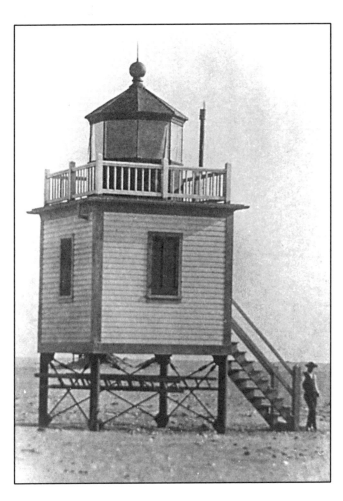

Hatteras Inlet Beacon, circa 1890s. One of only two photos known to exist of this light.

Sketch of Cape Hatteras Lighthouse keeper's house, 1862.

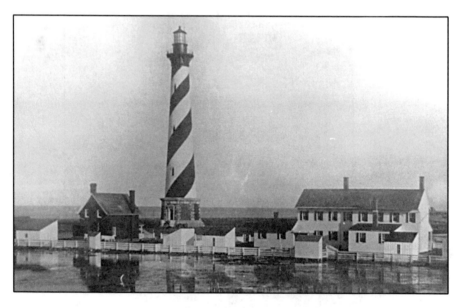

Cape Hatteras Lighthouse with keepers' quarters, outbuildings, and "mosquito farm," circa 1893. Mosquito farm was the term used for a pond that was formed by rain or overwash.

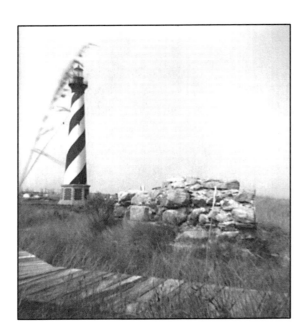

The remains of the original Cape Hatteras Lighthouse can be seen in this photo, 1963.

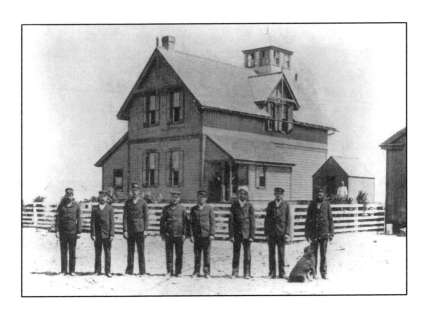

Cape Hatteras Lifesaving Station, no date.

The lower Outer Banks is bigger than the upper Outer Banks. Hatteras Island extends thirty-three miles, from Oregon Inlet to Hatteras Inlet. Hatteras Village is the southernmost village on the island. It is also where visitors go to catch the ferry to Ocracoke Island. In addition to the famous Cape Hatteras Lighthouse and the serene seashore, Hatteras Island is considered by many to have the best fishing on the Banks.

The lighthouse was painted in 1973 to help distinguish it from other nearby lighthouses. The paint pattern is often referred to as a black-and-white barber pole or "candy-striping."

By the 1920s, erosion had become a major problem. In 1936, a tower was built farther inland and the Cape Hatteras Lighthouse was abandoned. Its keeper, Cap'n Unaka B. Jennette, shut down the tower.

Other Points of Interest

Cape Hatteras National Seashore is made up of 30,318 acres of beaches and wildlife refuges. The park service closes some beaches during wildlife nesting seasons. Check their website for current information. 252-995-4474. http://nps.gov/caha

Visitors used to be able to drive and pitch their tents anywhere in the Cape Hatteras National Seashore.

Graveyard of the Atlantic Museum. The unusual design is for hurricane protection.

Frisco Native American and Natural History Museum is filled with exhibits pertaining to early inhabitants of Hatteras Island. There is also an observation area for bird watching and nature trails that extend into the maritime forest. Summer programs are offered. There is a gift shop too. 252-995-4440. www.nativeamericanmuseum.org

Graveyard of the Atlantic Museum chronicles the history of the Outer Banks. It has numerous exhibits about area shipwrecks, pirates, maritime history, and more including the "Lost Lens" from the first Cape Hatteras Lighthouse. A must see for visitors! 252-986-2995. www.graveyardoftheatlantic.com

Canadian Hole

If you like water sports, this is the place to be. Everything from scuba diving to windsurfing is possible. In fact, the Canadian Hole is *the* place for windsurfing. It was formed in the 1960s when a storm cut an inlet across the island. Dredging was done to rebuild NC 12. This created troughs as deep as five feet, perfect for windsurfing. This area became known as the Canadian Hole because surfers come from as far away as Canada to windsurf. More recently, sailboarding and kiteboarding have grown in popularity. This magical spot can be found one-and-a-half miles south of Avon.

Visitor Information

Yes, this lighthouse is open to the public! There are exhibits and a gift shop on site. Some restaurants and tour operators close in late fall until late spring. Be sure to check what's closed before planning your visit. Night climbs may be permitted during the summer months. What an incredible view—day or night! This endeavor should not be taken lightly though. In fact, it is advised that those who are not physically fit, or those who suffer from heart problems or breathing difficulties, should not try it. Remember, this is the tallest lighthouse in America—it is comparable to a twelve-story building.

Additional information about the climb:

- No pets allowed.

- No heels or bare feet permitted.

- Children must be at least forty-two inches tall and able to walk on their own (no carrying permitted).

- There are 248 narrow, iron, spiral steps to the top.

- There is a landing every thirty-one steps.

- There is a handrail on one side only and two-way traffic.

- It can be hot and humid inside the tower.

-

Getting There

The lighthouse is 61 miles south of Kitty Hawk at Buxton. If coming from the northern beaches, take US 158/Croatan Highway to Nags Head (about twelve miles). Turn left onto NC 12 South and proceed for forty-eight miles. 252-995-4474. www.nps.gov/caha

OCRACOKE LIGHTHOUSE

Closest city: Ocracoke, Hyde County

FAST FACTS

- It cost $11,359.35 to build this lighthouse and keeper's house.

- One keeper loved his job so much that he stayed for 45 years.

- Ocracoke is accessible only by private boat or ferry.

Ocracoke Island is a sixteen-mile-long barrier island, located off North Carolina's Outer Banks and made famous by Blackbeard, who used the tiny, uninhabited island as a hideout and hangout. In the beginning, it was known as "Pilot Town" because the village was founded by lightering pilots who guided ships through the shallow waters.

In 1715, Ocracoke became an official port. Within a few years, the population swelled. Part of the reason was the government gave inhabitants twenty acres apiece. With the growing population, it was decided that a lighthouse was needed.

Locals petitioned for the beacon to be built on nearby Shell Island instead. They felt it was needed there rather than on Ocracoke and they

Teach's Lights

Legend has it that the famous pirate, Blackbeard, once said that no one, save the Devil and himself, knew where he had hidden his loot. Whoever lived longer would get all the riches. It is said that on clear nights the waters around Teach's Hole at Ocracoke Island possess a unique shine and glimmer. This is when Blackbeard swims these waters in search of his head. It was chopped off during a bloody battle with the Royal Navy. Supposedly, anyone who follows these lights will eventually find Blackbeard's treasure. But beware! According to the legend, the Devil himself will be seated on top of the chest, waiting to receive his promised booty.

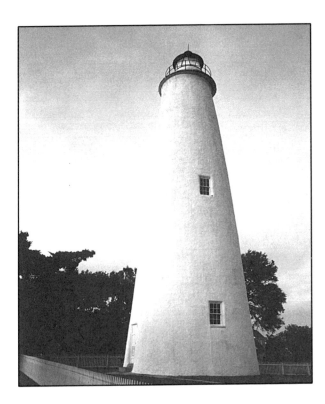

Ocracoke Lighthouse.

got their way. The tower was approved in 1794 and lit sometime between 1798 and 1803.

The pyramid-shaped wooden tower was anchored in a stone foundation and stood fifty-four-feet tall. The diameter of the tower was fifty feet at the base and twenty feet at the top. Its lantern held one huge, oil-fueled lamp. The beacon did its job until it was destroyed by lightning in 1818.

By this time, the channel had shifted and a beacon on Shell Island was no longer useful. A $14,000 lightship was placed at Ocracoke Inlet in 1820, but it didn't get the job done either.

Ocracoke Island, however, had become a major shipping port. During this time, Ocracoke Inlet was one of the busiest inlets on the East Coast. It was one of the few good waterways for reaching all inland ports, such as New Bern, Elizabeth City, and Edenton. No wonder Blackbeard loved this area! It was decided the lighthouse must be built on the

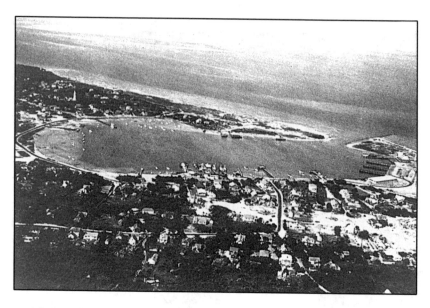

Aerial view of lighthouse and inlet.

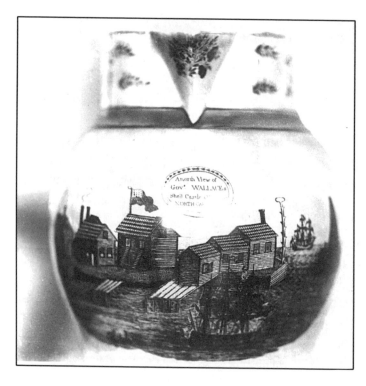

This Blount pitcher shows the entire Shell Island community. The Shell Island Lighthouse can be seen in the far right corner of the pitcher, no date.

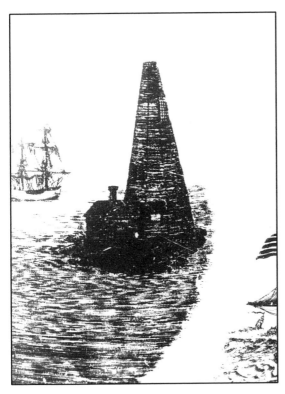

Another view of the Blount pitcher. This image is the only known recorded image of Shell Island Lighthouse, no date.

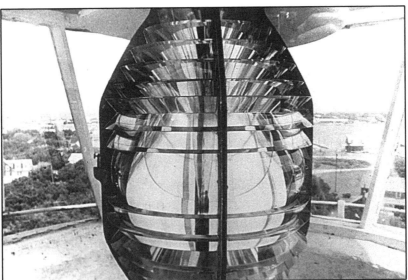

Fresnel lens used in the Ocracoke Lighthouse, no date.

In the late 1800s, a census showed a population of 139. In the 1990s, it was nearly 600. Nowadays, the year-round population is close to 800. In the summer months it swells to nearly 2000. Islanders are primarily employed in tourism and commercial fishing. In peak season, locals work sixty to eighty hours a week!

island. It was approved in 1822 and lit the following year. It was built on a two-acre site near Silver Lake Harbor. The builder was Noah Porter of Massachusetts. The total cost for the lighthouse and three-room keeper's house was $11,359.35.

Ocracoke Lighthouse stands sixty-five-feet tall or seventy-five feet above sea level. The tower is constructed of brick covered with plaster. At the base, the walls are more than five feet thick.

In the beginning, the tower housed a third-order Fresnel lens, which was replaced with a fourth-order Fresnel in 1854. The lens was removed by soldiers during the Civil War but replaced in 1864. The lighthouse was renovated after the war. A second floor was added to the keeper's house and by the early 1900s a walkway had been built between the beacon and the house.

In 1946, Ocracoke Lighthouse became automated. It was a sad day when Cap'n Joe Burrus had to leave. He had been the keeper of this light from 1929 until 1946. He also served at Cape Lookout Lighthouse and on the Diamond Shoals Lightship. He stayed on Ocracoke, moving to another residence. He died eight years later. His house stayed in his family until the 1970s, when it was bought by Ann Ehringhaus. She converted it into a bed and breakfast. According to some reports, Ann says that she has heard someone walking around upstairs on many a winter's night. But she does not find anyone when she goes to investigate. Ann is sure this is the spirit of Cap'n Joe.

Nowadays, there is a fixed white 8,000-candlepower light in the Ocracoke Lighthouse, which can be seen up to fourteen miles out to sea. While it is no longer needed, it is comforting to see this light switch on every evening at dusk.

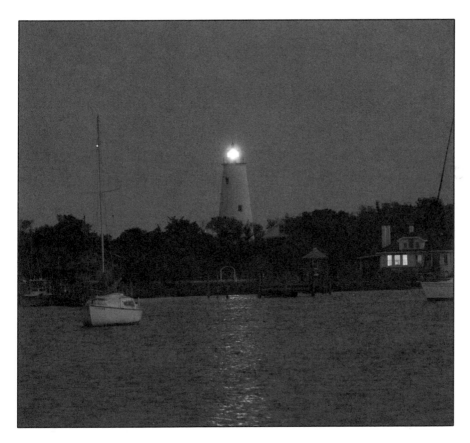

Ocracoke Lighthouse at night.

Other Points of Interest

Ocracoke Beach has been rated one of the best beaches in America by Dr. Beach. He has numerous criteria, such as sand softness, pests, runoff, litter, wildlife, and vista. Usually, one South Carolina and one North Carolina beach make his annual list.

Ocracoke Lighthouse, keeper's house. The two men posing are the keeper and assistant keeper and their families, circa 1890.

Ocracoke Village is on the National Register of Historic Places. It includes Ocracoke Lighthouse, Coast Guard Station, British cemetery (Royal Navy sailors killed in 1942), and other historical structures. Visitors can take a self-guided tour of its historic sites on an interpretive trail, which includes these sites and more. Beforehand, island visitors should check out **Ocracoke Museum**. It introduces visitors to the history of Ocracoke. It is located in a historic house at the edge of Ocracoke Village. 252-928-7375. www.ocracokepreservation.org

Ocrafolk Opry feature musical groups Molasses Creek and Coyote. Both were featured in the Warner Brothers movie, *Nights in Rodanthe*. The bands have performed across the U.S. and appeared on *A Prairie Home Companion* and *National Geographic*. Tickets are sold at the door nightly during the summer months (no reservations). The Deepwater Theater and Music Hall is on School Road. 252-928-3411, www.deepwatertheater.com

Wild Horses

The Ocracoke ponies are descendants of feral horses and symbols of Ocracoke's past. At one time, every family on the island had a horse or two. They all roamed free, breeding at will. They were not fed, but left to fend for themselves. They came into town looking for food and wandered into gardens in search of food.

There were "pony round-ups" or pennings once a year. The islanders made a party out of it, combining it with the Fourth of July celebration. The horses were branded, some sold during the roundup, and an unofficial rodeo was held.

In the 1950s, Ocracoke Island had the only Boy Scout troop on horseback, thanks to Major Marvin Howard, who retired to the island and became a troop master. Each boy was responsible for catching and training his horse. Troop 290 competed in horse races held on the beach at Buxton. Each boy was responsible for his horse during the ferry ride to Hatteras. The Ocracoke ponies usually beat Arabian and quarter horses! When the Boy Scouts of America required the troop to have insurance, they had to give up the horses.

The pony population dwindled and was nearing extinction in the 1970s when a national park service ranger stepped in. Jim Henning and his wife, Jeanetta, nurtured the herd and the number of ponies increased. Further breeding is planned to "maximize the gene pool." For their safety, the horses have been confined to a "pony pen" along NC 12. Visitors may see the pretty ponies from an observation platform.

North Carolina Ferry System

The state ferry system began in the mid-1920s when Captain Toby Tillett started a tug and barge service across Oregon Inlet. Today, North Carolina ferries take more than one million vehicles and 2.5 million passengers across five bodies of water (Currituck and Pamlico Sounds; Cape Fear, Neuse, and Pamlico Rivers) annually. The NC Ferry System offers seven routes with twenty-one ferries in operation. More than 400 workers are employed by the NC DOT ferry division. They have a full-service shipyard, tugs, barges, and other vessels.

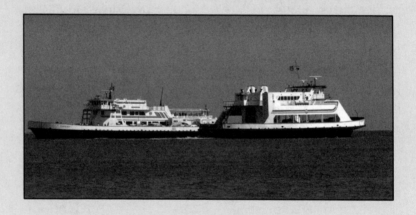

Portsmouth Island is the only seaside ghost town in the Carolinas, including a post office, school, church, houses, and lifesaving station. It is part of the Cape Lookout National Seashore. Step back in time as you explore this special place. It is interesting to note that in 1860, Portsmouth had nearly as many inhabitants as Ocracoke does today. Private ferry service available from Ocracoke. 252-728-2250. www.nps.gov/calo

Distance to the Outer Banks from

Asheville, NC is 460 miles

Charleston, SC is 450 miles

Jacksonville, FL is 624 miles

New York City, NY is 503 miles

Richmond, VA is 169 miles

Toronto, Canada is 827 miles

Atlanta, GA is 607 miles

Cleveland, OH is 632 miles

Quebec, Canada is 780 miles

Pittsburgh, PA is 413 miles

Savannah, GA is 492 miles

Wilmington, NC is 251 miles

Visitor Information

Ocracoke Island is part of the Cape Hatteras National Seashore and, except for the village, is owned by the National Park Service. The lighthouse is not open to the public but visitors can tour the grounds. The former keeper's house now houses National Park Service personnel.

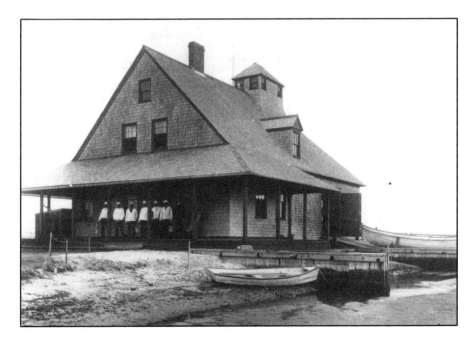

Portsmouth Island Lifesaving Station, no date.

Getting There

The only way to reach Ocracoke Island is by ferry from Hatteras Island, Swan Quarter, or Cedar Island. There is a big public parking lot at the south end of NC 12 between the Ocracoke Museum and the ferry office with a visitor center. Most visitors take the Hatteras-Ocracoke ferry. It is a pleasant forty-five minute ride from Hatteras to Ocracoke. To obtain a ferry schedule call 800-293-3779 or go to www.ncdot.org/ferry. There is a small airport, the Ocracoke Island Airport, which accommodates private planes. www.ocracokeairport.com

The island speed limit is a maximum of 20-25 mph and is strictly enforced. Everyone shares the road—cars, service vehicles, pedestrians, and cyclists. Like everywhere else, traffic is heavy during the heart of the summer.

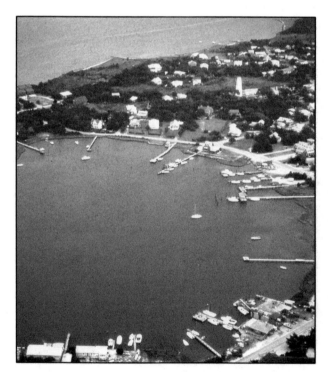

Aerial view of Ocracoke Lighthouse, village, and Silver Lake.

CAPE LOOKOUT LIGHTHOUSE

Closest city: Beaufort, Carteret County

FAST FACTS

- Keepers had to climb five flights of steps (197 steps) to get to the room that leads to the cupola that opens to the watch gallery.
- National Park Service volunteers can stay in the old keeper's house.
- Cape Lookout National Seashore is made up of 55 miles of islands.

Extending from the North Carolina coast 10 miles out into the Atlantic Ocean are the ever-shifting sands of Lookout Shoals. Many ships were wrecked on these shoals before a beacon existed.

Costing less than $21,000, the first Cape Lookout Lighthouse was approved by Congress in 1804 and completed in 1812. The ninety-six-foot-high beacon had too many problems to overcome. Its biggest problem was that it was not tall enough. Additionally, it had structural problems that were significant.

There are 201 steps to the top with seven stair landings. There are two doors and ten windows. A ship's hatch allows access to the gallery at the top.

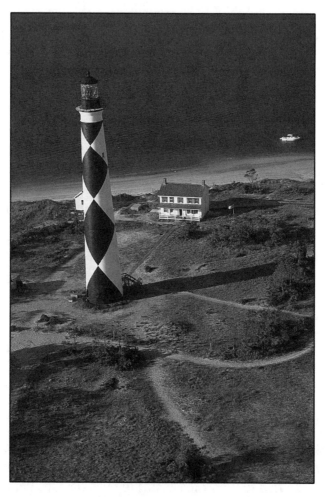

Aerial view of Cape Lookout Lighthouse.

A new lighthouse was approved in 1857, which was completed two years later. The big, brick structure became a model for all lighthouses constructed on the Outer Banks from that point on. The $45,000 tower is an impressive 169 feet above sea level or 163 feet tall, and had a first-order Fresnel lens. The double walls are nine feet thick at the base. This tapers to less than two feet thick at the top. The light could be seen nineteen miles out to sea. The lighthouse was painted with a distinctive black-and-white diamond pattern.

During the Civil War, the Cape Lookout area was a military strong-hold until the Confederates were forced to retreat. Before doing so, they tried to blow up both lighthouses so that the Union could not use them. The original lighthouse was destroyed but the second lighthouse was only mildly damaged.

The following year, the lighthouse was relit using a third-order Fres-nel lens. It was replaced when the first-order Fresnel was repaired. A lightship was placed at Cape Lookout in 1904 to help mariners because sometimes the waves were so high they obstructed the light.

By 1914, the fixed light was changed to a flashing white light. The light became automated in 1950 and the Fresnel lens was removed in 1975. The current optic is a DCB-24 (two rotating airport beacons). Each 1000-watt bulb produces 800,000-candlepower. The light, which flashes once every fifteen seconds, can be seen nineteen miles out to sea. There is a generator for back-up lighting at the base of the beacon.

The biggest danger this lighthouse faces is erosion caused by tidal currents in Bardens Inlet. Continued dredging must be done to keep a channel open to the inlet, which helps protect the lighthouse.

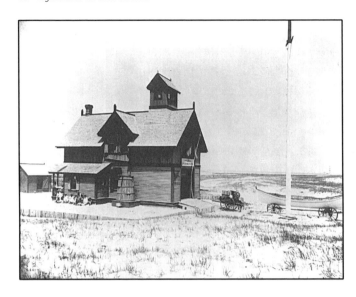

Cape Lookout Lifesaving Station, no date.

Other Points of Interest

Cape Lookout National Seashore consists of three uninhabited barrier islands: North Core Banks, South Core Banks, and Shackleford Banks. Visitors will discover more than fifty-eight miles of unspoiled beauty, including the legendary Shackleford ponies. Harkers Island Visitor Center is at 131 Charles Road. 252-728-2250. www.nps.gov/calo

Fort Macon State Park is one of the most visited parks in the state. It has a long and intriguing history. The fort can be found on the eastern tip of Bogue Banks. The visitor center is at 2300 East Fort Macon Road, Atlantic Beach, NC 252-726-3775. www.ncparks.gov/Visit/parks/foma.

NC Aquarium at Pine Knoll Shores has numerous exhibits that are fascinating for all ages. 252-247-4003. www.ncaquariums.com

North Carolina Maritime Museum has all kinds of exhibits detailing our coastal history. 315 Front Street, Beaufort. 252-728-7317. www.nc-maritime.org

The Outer Banks are mostly barrier islands, which are created when sand is moved. This explains why erosion is such a problem—because the sand is perpetually moving. Some barrier islands become uninhabitable when this happens. This is also why inlets open and close.

Visitor Information
The lighthouse and keeper's quarters are open during the summer months and visitors may make the 12-story hike up the 201 spiral stairs to the top. The original keeper's house was moved elsewhere on the island as a private residence. The assistant keeper's house contains a little museum and visitor center. Cape Lookout National Seashore. 131 Charles Street, Harkers Island. 252-728-2250.

Lady Keepers of the Light

Two women keepers served here: Charlotte Ann Mason Moore, assistant keeper (1872–1875) and Emily Julia Mason, keeper (1876–1878).

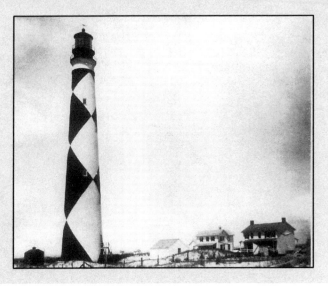

Harkers Island is a good place to see the lighthouse without having to hire a boat. It is also where you'll find boats that will take you to the lighthouse for a fee.

Getting There

Harkers Island is twenty miles east of Beaufort. Take US 70 East to Harkers Island. Follow Harkers Island Road until it dead-ends at the eastern end of the island. There you'll find a two-story visitor center with exhibits, a gift shop, and the Core Sound Waterfowl Museum. That's about all there is in the way of tourist attractions on this island.

BALD HEAD ISLAND LIGHTHOUSE

Closest city: Southport, Brunswick County

FAST FACTS

- The first Bald Head Light dates back to 1795.
- Old Baldy was used by the Navy during World War II.
- The tower is like a bulldog—so ugly that it is cute.

This fourteen-mile-long island got its nickname from the dunes on its south beach. River pilots stood on these dunes watching for ships that needed their help to make it safely up the river. These dunes became so worn down that they came to look like a bald head.

It was once called Smith Island because Thomas Smith bought it in 1690 from the colonial Lords Proprietors. Early maps show a Smith Island, but by the 1770s, maps began referring to this land mass as Bald Head Island.

It made sense to put a lighthouse here, not only to guide ships entering the labyrinth of channels and sandbars of the Cape Fear River, but also to help vessels avoid the treacherous Frying Pan Shoals, which extend more than twenty miles into the ocean.

Cape Fear River

Sailors didn't like traveling the 202-mile Cape Fear River. In fact, the river got its name because sailors feared its labyrinth of channels and treacherous sandbars. The black-water river runs from central North Carolina to south of Wilmington where it joins the Atlantic Ocean.

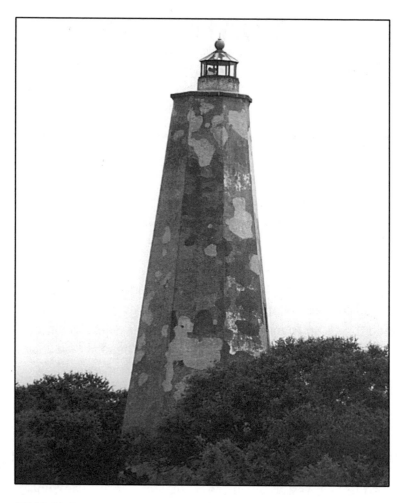

"Old Baldy."

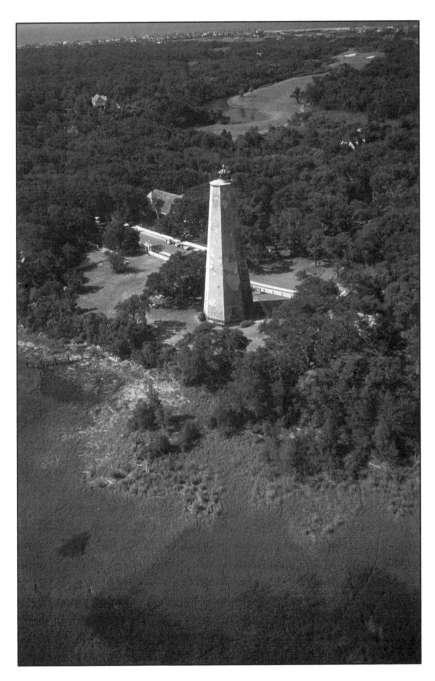

Aerial view of Bald Head Island Lighthouse.

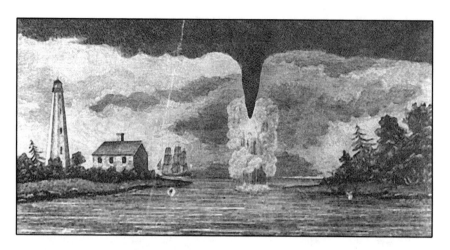

Sketch of the original Bald Head Light Station, 1805.

Until the 1990s, the island was separated from the mainland by an inlet, but thanks to Hurricanes Fran and Floyd the inlet doesn't exist anymore. So, technically, Bald Head Island is not an island anymore.

The Bald Head Island Station was the state's first lighthouse. It was completed and lit in 1795. Due to structural problems and erosion, this lighthouse was not sufficient.

By 1816 a new lighthouse had been approved. "Old Baldy" was lit in 1817. It is thirty-six feet wide and the walls are five feet thick at the base. The foundation and platform for the lantern room are stone, the tower is brick covered with plaster. Some of the tower bricks reportedly came from the original 1795 lighthouse.

The ninety-foot beacon with a fourth-order Fresnel lens had a limited range, so a lightship was placed at Frying Pan Shoals from 1854–1964. The ship was ultimately removed because of the danger from hurricanes. In 1855, a fog bell was placed near Old Baldy and the light was upgraded to a third-order Fresnel.

The lighthouse was shut down during the Civil War. A fort was built, which was abandoned in January 1865 after the fall of Fort Fisher. When it was reactivated, the light was changed back to a fourth-order Fresnel. A jetty was built to thwart erosion. In 1883, a big, two-story keeper's house was built.

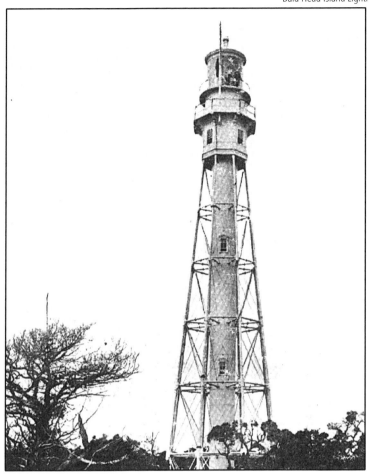

Cape Fear Lighthouse, circa 1906.

Frying Pan Lightship, 1972.

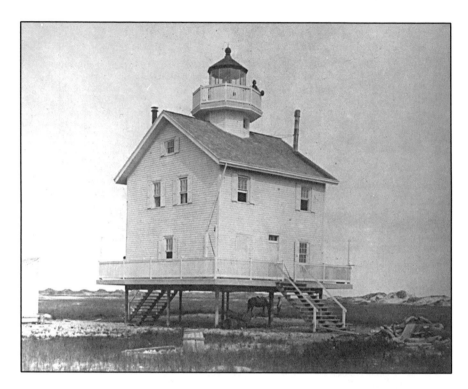

Federal Point Lighthouse, 1866. This lighthouse was no longer used after 1879 and was destroyed by fire in 1881. Look closely and you can see an unidentified man and a horse on the other side of the house.

In 1903, Cape Fear Lighthouse was built on Bald Head Island. The wrought-iron-and-steel-frame tower cost $70,000 to construct. Part of this cost included building a pier and tramway to haul the building materials the four-mile distance from the water to the lighthouse site. Supplies had to be put into an iron-wheeled flat car that was pulled by mules. The 150-foot skeletal tower housed a first-order Fresnel lens with a range of nineteen miles out to sea.

The assistant keeper for many years, Devaney Farrow Jeanette, died of a heart attack in 1932. He had just climbed all the stairs to the top to relieve Captain Charles Norton Swan, when he collapsed and died. Cap'n Charlie was keeper of the light from 1903–1933. It probably wasn't a coincidence that he retired a few months after this incident.

Captain "Sonny" Dosher was a long-time keeper at Bald Head Lighthouse.

This lighthouse was decommissioned in 1958 when the Oak Island Lighthouse was lit. Dynamite was used to destroy the old lighthouse. All that remains of the Cape Fear Lighthouse is the concrete bases.

Old Baldy continued to be active until 1935. The Fresnel lens was replaced with a radio beacon during World War II. Troops patrolled the beaches on horses looking for Germans. The beacon remained active until 1958. In 1963 the lighthouse was sold to a private citizen who eventually sold it to Carolina Cape Fear Corporation. They donated the lighthouse to the Old Baldy Foundation, who takes care of it. The keeper's house no longer exists but the brick oil house now houses restrooms.

Generator house for Cape Fear Lighthouse.

In the 1970s, island development began but was stalled by a recession. In the early 1980s, Bald Head Island Ltd. took over and built a marina and store. At this time, 10,000 acres of lush marsh and forest were donated to Bald Head Island Conservancy for preservation and protection.

Old Baldy is the first thing that visitors to the island see. It stands proudly, welcoming all those who come to spend time on this lovely island.

Renting (Ghosts Included!)

The grounds of Bald Head Island Lighthouse can be rented for special occasions like weddings. The inside of the lighthouse can be rented too, but no food or drinks are permitted. 910-457-7481. www.oldbaldy.org

There are three historic cottages, known as Cap'n Charlie's Station (named after long-time Cape Fear Lighthouse keeper Cap'n Charlie), that visitors can rent. The cottages are reportedly haunted by three different ghosts! Two- and three-bedroom cottages can cost more than $3,000–$4,000 a week in season.

now

then

The island has hosted many colorful characters such as the nefarious pirate Stede Bonnet, rumored to have camped out on the island once or twice, probably while hiding from authorities. Others include marsh wrens, alligators, loggerhead turtles, wild hogs, bootleggers, and crop farmers. A hotel was built near the lighthouse but never completed due to financial problems. It was later torn down.

Other Points of Interest

Bald Head Island Conservancy is a great place to learn about island ecology. You can even sign up for an alligator walk or a turtle walk. Visitors can see exhibits, hear stories, and buy souvenirs. 910-457-0089. www.bhic.org

Smith Island Museum of History is housed in a replica of the former keeper's house and features items pertaining to this lighthouse's history, as well as the Cape Fear Lighthouse. 910-457-5003. www.oldbaldy.org

Visitor Information

This lighthouse is open to the public! Visitors can climb 112 steps to the top for a great view of the area. Visitors should note that a 2000 census shows the permanent population was less than 200, but by 2010, it is more than 2,000. And that number swells to about 10,000 during the summer months! There are only a few restaurants on the island so expect long lines at peak times. There are also some tourist shops, a golf club, a marina, a grocery store, and a chapel. 910-799-4640 or 910-457-7481. www.oldbaldy.org

Getting There
The island can be reached only by private boat or the privately-owned passenger ferry that departs from Indigo Plantation Marina in Southport. There is paid parking here. It is a twenty-minute ride aboard a private ferry. Once on the island, transportation is by foot, bicycle, or golf cart. Bicycles and golf carts are usually provided through island lodging or they can be rented.

To get to Southport, take 211 south, turn right onto West 9th Street, and follow the road about one-and-a-half miles to Indigo Plantation. The road dead-ends into the ferry terminal (Deep Point Marina) and ticket office. 910-457-5003. There is another ferry terminal in Southport—the state ferry to Fort Fisher—so be sure you are headed to the right place.

Distance to Bald Head Island from
Wilmington, NC is 34 miles
Cleveland, OH is 797 miles
Myrtle Beach, SC is 70 miles

DIAMOND SHOALS AND FRYING PAN SHOALS LIGHT TOWERS

Frying Pan Shoals Light Tower and Diamond Shoals Light Tower were two of only seven offshore East Coast light stations. These light towers are often referred to as "Texas" towers, since they resemble the massive steel structures used in offshore oil drilling in Texas. The Diamond Shoals Light Tower sat twelve miles from Cape Hatteras. When it was operational, there was a foghorn, a radio beacon, and a light that flashed every ten seconds. It could be seen eighteen miles out to sea. The light became solarized in 1994, decreasing the light's range to twelve miles. There was a galley, eight bedrooms, and a communications center. It was decommissioned in 1994.

Frying Pan Shoals Light Tower cost $2 million to construct in 1964. The "house" was transported by barge from Louisiana to Frying Pan Shoals, which lies thirty-two-and-one-half miles southeast of Cape Fear. It was lifted and then attached to its massive foundation by a huge crane. The structure was supported by four steel posts each measuring forty-two inches in diameter. Its steel legs extended almost 296 feet below sea level to securely anchor the 550-ton house. On the lower levels were the boat and tank decks. The next level was the Quarters Deck, an 8,100-square-foot deck that was the crew's living space. Above this level

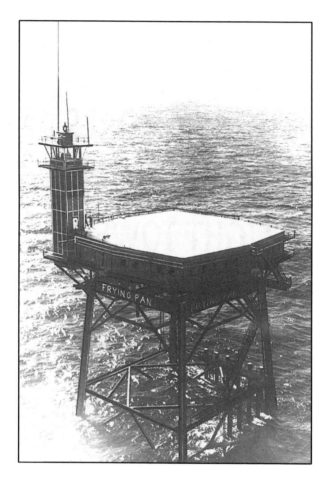

Frying Pan Shoals Light Tower, circa 1980.

was the helicopter pad, which doubled as an exercise and recreation area. The original lighting apparatus was a DCB-224 optic, which had a range of twenty miles. The light was switched to solar in 1996, decreasing its range to sixteen miles. The new lighting system consisted of eight 35-watt solar panels that powered a rotating beacon with a 50-watt, 12-volt lamp. A back-up system was also included. The tower was automated in 1979, so there was no further need for keepers.

Both towers were manned by six Coast Guard personnel. The rotation called for four crew members to stay onboard while two had shore

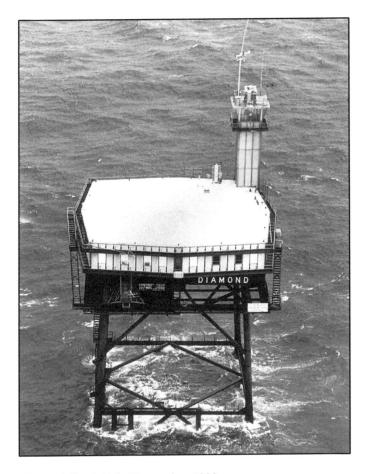

Diamond Shoals Light Tower, circa 1980.

leave. Duty was two weeks on and one week off. These towers took a serious beating when Hurricane Fran hit North Carolina. Both had become unsafe to access either by boat or helicopter so maintenance became impossible. In 2007, Diamond Shoals Light Tower was sunk to make an artificial reef. Frying Pan Shoals Light Tower was sold at auction in 2010 for $85,000 to a software sales engineer, Richard Neal. He plans to turn the old light tower into a remote retreat. Repairs are estimated at more than $1.5 million, likely a conservative figure. I can only imagine what the liability insurance will cost!

OAK ISLAND LIGHTHOUSE

Closest City: Town of Caswell, Brunswick County

FAST FACTS

- The base of the lighthouse is anchored more than 70 feet below ground so that it is strong enough to support the massive tower.

- Helicopters were needed to put the lamp on top of the tower.

- This is one of the last lighthouses built in America and is one of the most powerful in the world.

In 1849, Oak Island Range Lights were completed to help guide ships into North Carolina's biggest port, Wilmington. Most of the state's inland lights had the same design: a tower built atop a keeper's house, with a second beacon, or rear range light, built nearby. Oak Island Range Lights were different. Both were free-standing brick beacons and there was a separate one-and-a-half-story keeper's house. The half story was the

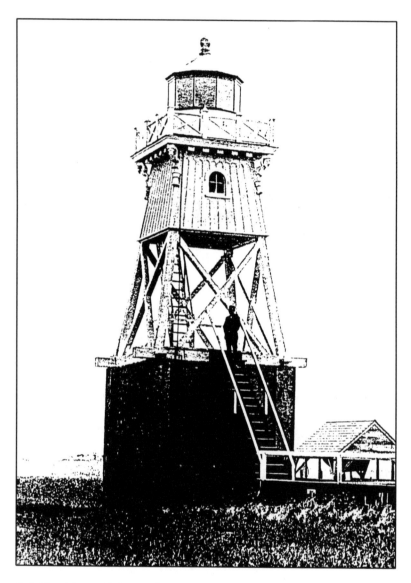

Oak Island Range Light, no date.

sleeping space.

These range lights were destroyed during the Civil War. They were rebuilt in 1879. The front range light was a wooden tower secured to a

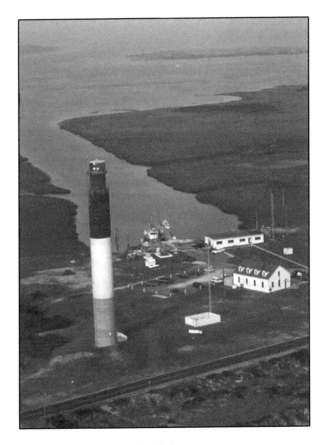

Aerial view of Oak Island Lighthouse.

sixteen-foot-high brick foundation. The rear light was also wood, mounted on skids so it could be moved when the channel shifted periodically. These lights were also called the Caswell Lights because of the close proximity to Fort Caswell.

By 1894, these lights were taken out of service. Soon thereafter, a lighthouse was approved to be built on Bald Head Island. Cape Fear Lighthouse was lit in 1903. It was decommissioned in 1958 when a modern lighthouse was built on Oak Island.

The Oak Island lighthouse was the last lighthouse built in North Carolina. It was activated on May 15, 1958. It is 169 feet high and is made of eight-inch-thick reinforced concrete. The black-and-white paint was mixed with concrete so that the beacon would never need painting.

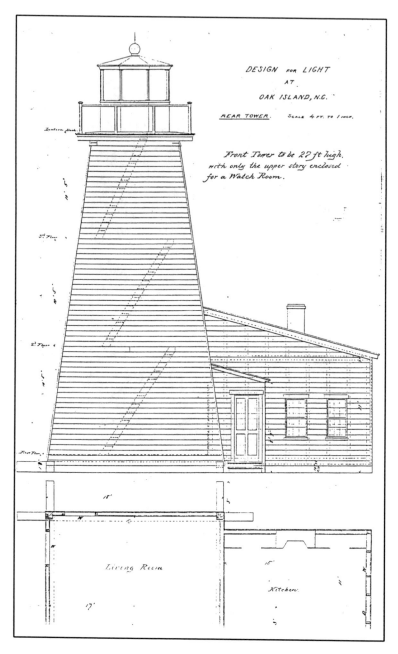

Diagram of rear tower of Oak Island Light Station. The illustration shows there was a living room and kitchen at the base of the tower, 1865.

Oak Island Range Light Station, 1893.

U.S. Coast Guard Station, Southport, no date.

Price Creek Lighthouse

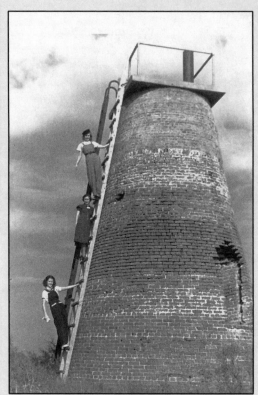

Price Creek Lighthouse was the last inlet light to be placed along the Cape Fear River. It was built in 1849 but was destroyed by storms sometime between the late 1800s and early 1900s. The second beacon was a twenty-foot circular brick structure that was later extended another six feet. This beacon was damaged during the Civil War. By 1881, a seawall was built that eliminated river traffic along this part of the Cape Fear River. There is not much left of this lighthouse. The windows are missing, the lantern room has been removed, and there is a huge hole from a hit during the Civil War. It sits on private property so it cannot be visited or seen from elsewhere. There has been discussion for several years about moving and restoring the lighthouse but so far nothing has happened.

Distance to Oak Island from
Trenton, NJ is 489 miles
Charlotte, NC is 253 miles
Corolla, NC is 197 miles

Two Marine helicopters were needed to put the lamp into place. The tower uses four revolving 1000-watt aerobeam lights, which flash intermittently and can be seen twenty-four miles out to sea. With 2,500,000-candlepower, Oak Island is one of the most powerful lighthouses in the world. Anyone doing repair work during operating hours has to wear protective clothing.

A shaft with a pulley and attached metal box is visible upon entering the base of the lighthouse. This is used to haul tools and lamps to the top of the tower. To get to the platform, lighthouse keepers must climb the 134 steep, metal steps located to the left of the shaft. The keeper reaches the lantern room by a fourteen-rung metal ladder. This room is so crowded with four huge rotating lights that it is almost impossible to enter while the lights are on without risking serious injury.

Oak Island was the last manually-operated lighthouse in the world. It is now functional day and night. It is switched on each evening from the base of the tower at thirty minutes before sunset, and switched off each morning at thirty minutes past sunrise.

Other Points of Interest

Cape Fear Museum is on Market Street in nearby Wilmington. 910-798-4350. www.capefearmusem.com

Fort Fisher played an important role during the Civil War. 1610 Ft. Fisher Blvd. South, Kure Beach. 910-458-5538. www.nchistoricsites.org/fisher/fisher.htm

NC Aquarium at Fort Fisher. See alligators, sea turtles, stingrays, and more. 900 Loggerhead Road, Kure Beach. 866-301-3476. www.ncaquariums.com/fort-fisher

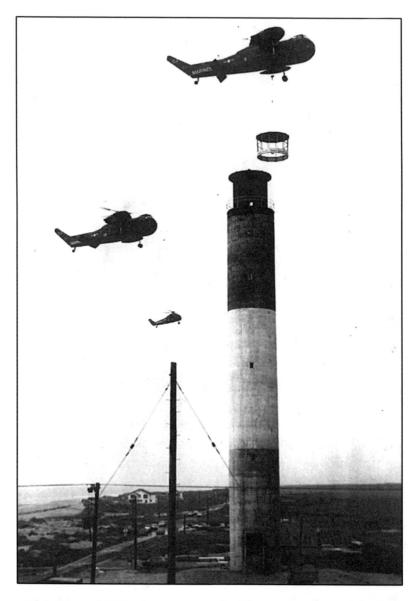

The helicopter is lifting the crown into place on the Oak Island Lighthouse, circa 1958.

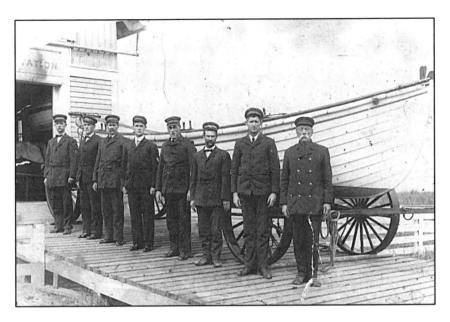

Oak Island Coast Guard Lifesaving Station, Southport, no date.

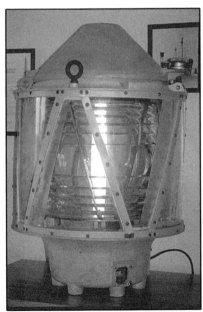

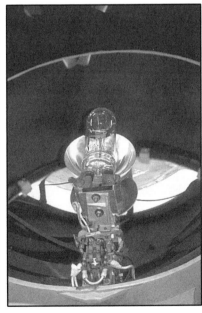

First-order Fresnel lens on display at Coast Guard Station, Oak Island.

Close-up of lighting apparatus and aerobeams of Oak Island Lighthouse.

Southport Maritime Museum houses nautical memorabilia from the Cape Fear area. 116 N. Howe Street, Southport. 910-457-0003.

Visitor Information
The lighthouse is open to the public! For many years, the lighthouse was part of the Coast Guard compound. For this reason, it was not open to the public. Recently, it was given to the Town of Caswell. A fence was built to separate it from the Coast Guard compound. Visitors can go to the second level (but not the top) of the lighthouse seasonally. Appointments can be made to climb to the top. Children under seven years old cannot take the tour. 300A Caswell Beach Road, Oak Island. www.oakislandlighthouse.org

Getting There
Take NC 133 from Southport to Caswell Beach. At the end of the highway, the road curves to the left. The lighthouse is about three miles from the bridge that connects this strip of coastline to the mainland. You can't miss it!

SOUTH CAROLINA
LIGHTHOUSES

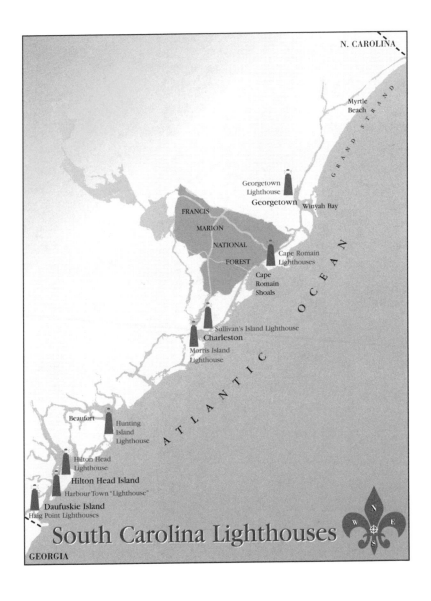

GEORGETOWN LIGHTHOUSE

Closest city: Georgetown, Georgetown County

FAST FACTS

- The light stays on day and night.
- The lighthouse is on an uninhabited island.
- There was a radio station at the lighthouse that was used by the Navy during World War II.

Georgetown was established in 1732, making it the third oldest port in South Carolina. The town was named in honor of King George I of England. At one time, Georgetown exported more rice than any other port in the world. With all this water traffic, a lighthouse was needed to guide ships into the harbor or to help them get safely past the peninsula between the Waccamaw River and the Atlantic Ocean.

In 1789, a Georgetown resident donated the land needed for the lighthouse, but it was several years before the government approved the lighthouse. This was due to politics and government bureaucracy. Finally, the government bought a different parcel of land in 1795. Records do

Everything shipped from Georgetown had to go through Charleston, where the customs office was located, until Georgetown was finally recognized as a port in 1732. This was important because prior to this, planters had to pay hefty freight charges for using Charleston's port.

not indicate whether the donated land was no longer available or the government deemed it unsuitable. It was another four years before construction began and two more years before the Georgetown Lighthouse was lit. The reason for these delays is unknown.

The lighthouse is on North Island, which is at the entrance to Winyah Bay and Georgetown. That is why locals and some records refer to it as the "North Island Lighthouse."

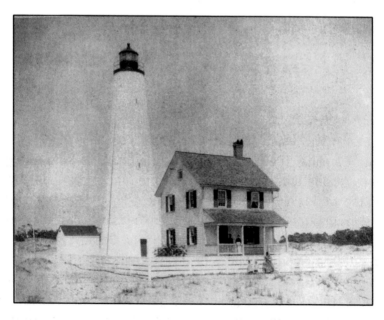

Georgetown Lighthouse and keeper's house, 1893.

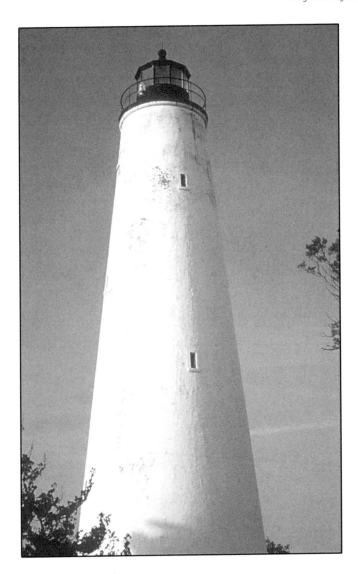

Georgetown Lighthouse.

Georgetown Lighthouse was seventy-two-feet tall with a lantern that was six feet in diameter. Originally, the lamp was lit using whale oil. This lighthouse was destroyed by a storm less than five years after it was built.

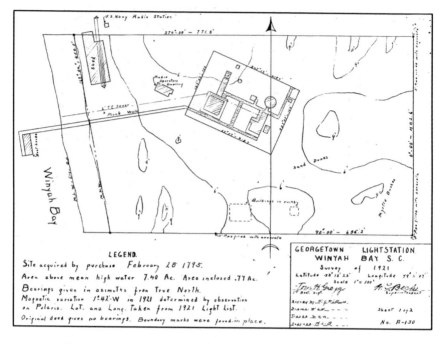

Diagram of lighthouse site, 1921 survey.

North Island has hosted many famous people over the years. The Marquis de Lafayette came to North Island in 1777. President Grover Cleveland was a guest of island owner Confederate General Edward Porter Alexander, who brought the president to the island on a duck hunting expedition. It was later owned by William Yawkey, owner of the Detroit Tigers. His nephew, Tom Yawkey, later assumed responsibility for the island. He bought nearby South and Cat islands too. Upon his death, he left the islands to the state, along with a $10 million fund for managing the Tom Yawkey Wildlife Center.

A second beacon was built in 1812. It also had a height of seventy-two feet. The tower was made of brick and then painted white. During the Civil War, Confederate soldiers used the lighthouse as an observation tower until it was captured by Federal troops in 1862. The lighthouse suffered significant damage during the war.

It was rebuilt in 1867. This time it was taller, with a height of eighty-seven feet. A fourth-order Fresnel lens was used, but has since been removed. The base is twenty feet in diameter and the walls are six inches thick. There are 124 stone steps up to the lantern room.

The U.S. Navy had a radio station at the lighthouse during World War II. The station and dormitory are still there. Also, there is a two-story keeper's house, an oil house, and a cistern. Everything, including the lighthouse, is enclosed by a white picket fence.

The Georgetown Lighthouse is the state's oldest active lighthouse. After the era of lighthouse keepers, the U.S. Coast Guard became the keepers of this light until 1986 when it became automated. Today, the optic is a solar-powered VRB-25 inside a fifth-order Fresnel lens. The light can be seen up to twelve miles away. Since there is no timing device, the light is always on. The Coast Guard decided that was cheaper than putting in a timing system. There are two back-up lights powered by battery packs in case a light burns out.

Other Points of Interest
Yawkey Wildlife Preserve offers tours by reservation. The preserve encompasses the North, South, and Cat islands but tours are only available for South Island. Participants are taken to the island by private ferry. The lighthouse can be seen from here. 843-546-6814.

Distance to Georgetown from
Myrtle Beach, SC is 38 miles
Aiken, SC is 196 miles
Greenville, NC is 227 miles

Georgetown Visitor Center offers a list of local tour companies. Some companies offer trolley tours of the historic district while others offer boat tours whereby the lighthouse can easily be seen. 843-546-8436. www.visitgeorgetowncountysc.com

Visitor Information

The tower is not open to the public. It is owned by the South Carolina Department of Natural Resources. It is on North Island, a fifteen-mile-long wildlife refuge which is accessible to the public. The area around the lighthouse has been cleared but the rest of the island remains untouched. The lighthouse is on the northern side of the entrance to Winyah Bay. North Island is twelve miles from Georgetown, a short boat ride away. There is a boat launch on Boulevard Street in Georgetown.

Getting There

Take Highway 17 and follow the signs to Georgetown. Check out www. lighthousefriends.com for a list of boat operators that will take you out to the lighthouse.

CAPE ROMAIN LIGHTHOUSES
Closest city: McClellanville, Charleston County

FAST FACTS

- The lighthouses sit on a seventy-five-acre island that is inhabited only by wildlife and goats that someone brought to the island, presumably to help with vegetation overgrowth.

- Boaters use the lighthouses as a daymarker so they know where they are.

- Due to the tides, there is only a small window of time when visitors can reach the island.

The government recognized the need for a lighthouse here and approved the expense in 1823. The Cape Romain Lighthouse was built near the entrance of the Santee River in 1827. It cost $8,425 including the keeper's quarters. A timber piling foundation supports the round brick tower. It was supposed to have a visibility of up to eighteen miles out to sea. After numerous complaints, the light was modified in 1847 to include eleven lamps and reflectors. Despite these improvements, the lighthouse still did not help mariners avoid the hazardous nine-mile Cape Romain shoals.

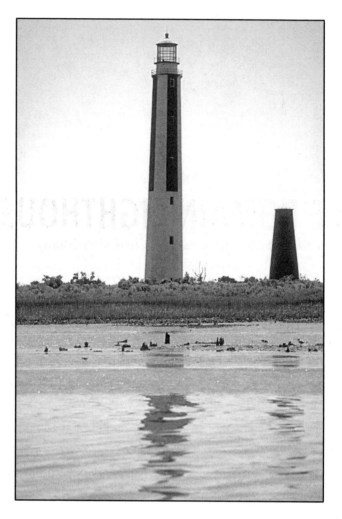

Cape Romain Lighthouses.

Cape Romain was named in honor of St. Romano. This land was discovered on St. Romano's birthday.

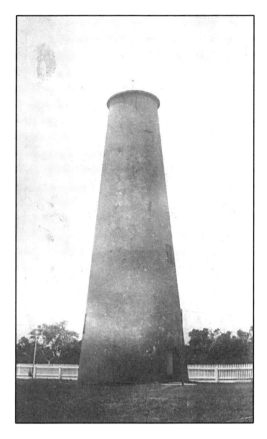

Old Cape Romain tower, 1913.

The lighting apparatus and lantern room were removed but the lighthouse was otherwise left intact. This was unusual because when new lighthouses were built, the old ones were usually destroyed. Records do not show why the 1827 light was left alone.

A taller, more modern lighthouse was approved. During construction, it was discovered that the walls of the tower were out of plumb. Its concrete foundation had settled on one side, making the tower twenty-four inches from the vertical. This problem was never corrected, so the 150-foot octagonal light-

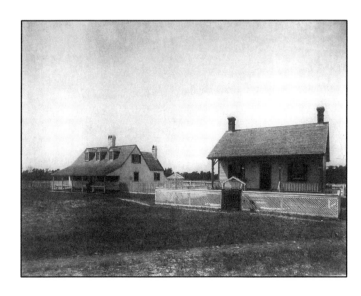

Cape Romain keeper's quarters, 1827-1858.

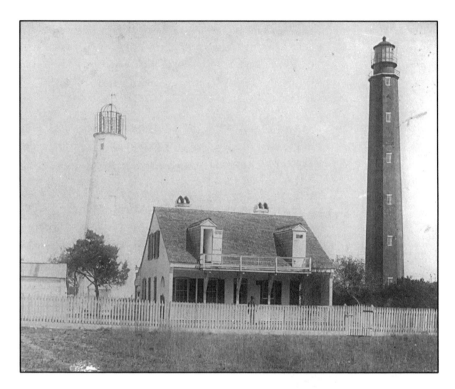

Cape Romain Lighthouses and keeper's house, 1893. The man behind the fence is presumably a keeper. Notice that one of the upstairs dormer doors is open, presumably from when a keeper stepped outside recently.

house leans slightly. It has been nicknamed "The Leaning Lighthouse." It was painted white with alternating black-and-white vertical strips covering the upper two thirds.

Keepers had to climb a 195-step spiral stairway to reach the lantern room. The lantern room housed a first-order Fresnel lens that offered visibility up to nineteen miles out to sea. The lighthouse was damaged during the Civil War but repaired in 1866.

The lighting apparatus was replaced in 1931 with a revolving bull's-eye lens blanketing a 500-watt bulb, which was powered by a new generating plant on the island. Six years later, the light was replaced again with an automated 1,000-candlepower beam.

The Coast Guard decommissioned the beacon in 1947, replacing it with lighted buoys. All the outbuildings were destroyed at that time with

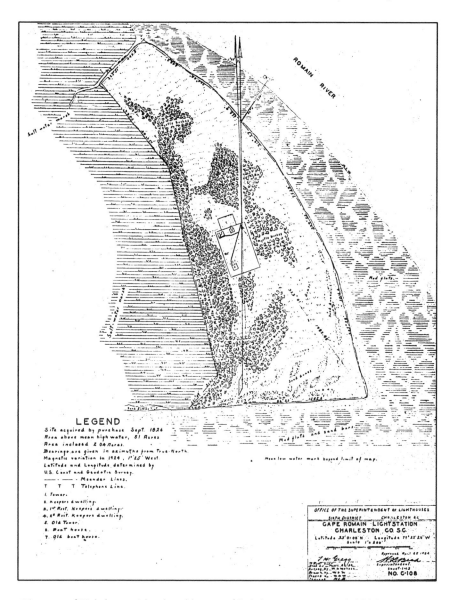

Diagram of Lighthouse Island and layout of lighthouse compound, 1924.

the exception of the keeper's house. It was removed in the 1950s as was the generating plant.

Cape Romain Wildlife Refuge

The refuge was established in 1932 and is part of the Carolinian-South Atlantic Biosphere Reserve. It hosts the largest nesting population of loggerhead sea turtles outside Florida. It is also a huge nesting rookery for brown pelicans.

Other Points of Interest

Bull Island is part of the 65,000-acre Cape Romain Wildlife Refuge and is one of the few places where visitors can access the refuge. The island hosts more than 270 species of birds, raptors, alligators, and lots of other wildlife. For more information on the refuge, visit www.fws.gov/caperomain. 843-928-3368.

Coastal Expeditions takes visitors to the island aboard a pontoon boat. It is a lovely thirty-minute ride through saltwater marsh creeks where visitors are often rewarded with sightings of dolphins and many pretty birds. Beautiful shells can be collected on the six-mile beach and there are footpaths through the maritime forest. It is a mile walk from the boat landing to the island's beach. Be sure to wear insect repellent when visiting any of the islands or beaches discussed in this book. www.coastalexpeditions.com

Village Museum at McClellanville is a small museum but offers an excellent overview of area history. It is located at the end of Pinckney Street next to the Town Hall. 843-887-3030. www.villagemuseum.com

Visitor Information

The lighthouses, owned by the U.S. Fish and Wildlife Service, are not open to the public. They are on Lighthouse Island, which is about a forty minute boat ride from McClellanville. The boat launch is at the Town Hall and Village Museum. Contact the tourism bureau to get a list of companies that offer harbor cruises with lighthouse views. You may even glimpse the goats that like to hang around the lighthouses. It's uncertain

where they came from, but they don't seem to mind the remote location. 843-546-8436. www.visitgeorgetowncountysc.com

Getting There
The island is about seven miles from McClellanville. From Charleston, take Highway 17 north about sixteen miles. Turn right onto Sewee Road. Go three miles and turn right again onto Bull Island Road. The road ends at the boat landing. From Georgetown, take Highway 17 south for about thirty-three miles. Turn left onto the second Doar Road turn-off. Then take an immediate right onto Sewee Road. Go four miles and turn left onto Bull Island Road. The road dead-ends into the boat landing.

MORRIS ISLAND LIGHTHOUSE

Closest city: Folly Beach, Charleston County

FAST FACTS

- The first shot of the Civil War was fired from Morris Island. The first Morris Island Lighthouse was destroyed during this war.

- Union soldiers built a temporary light during 1863 after the Confederates blew up the original Charleston Light (now called Morris Island Lighthouse).

- The lighthouse has survived wars, earthquakes, hurricanes, erosion, and neglect.

This is the most historically significant lighthouse in South Carolina. In 1767, King George III of England ordered that a lighthouse be built on Morris Island. At that time, Morris Island was actually three islands: Middle Bay, Morrison, and Cummings Point. The light was built on Middle Bay. It is one of only two lighthouses south of Delaware Bay to survive the Revolutionary War. The 102-foot lighthouse was fueled by lard oil, had a revolving lamp, and could be seen twelve miles out to sea.

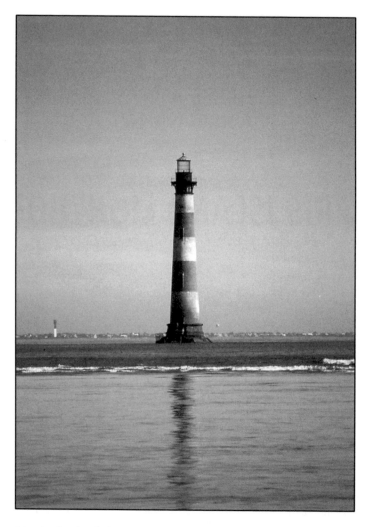

Morris Island Lighthouse with glimpse of Sullivan's Island Lighthouse in the background.

In 1790, the channel shifted, creating one big island where there used to be three separate islands. The new island was called Morrison Island, and later changed to Morris Island.

In 1858, a first-order Fresnel lens was installed. Sadly, the lighthouse was blown up during the Civil War. Confederates didn't want Union soldiers to use it as a lookout tower.

In 1873, Congress approved the building of another lighthouse on Morris Island. Three years later, the Charleston Light was lit. It was located 400 yards southeast of the original tower site because of the shifting channel. The $150,000 lighthouse stood 161 feet tall. It was designed to look like Bodie Island Lighthouse on North Carolina's Outer Banks. It was even painted with black and white horizontal striping, the pattern on Bodie Island Lighthouse.

The tower is built on 268 wooden timber pilings that extend fifty feet below ground. The foundation is eight feet thick with a diameter of thirty-three feet at the base. There are nine stories of steps leading up to the lantern room. The light was fueled by acetylene and was covered by a first-order Fresnel lens, which could be seen nineteen miles out to sea.

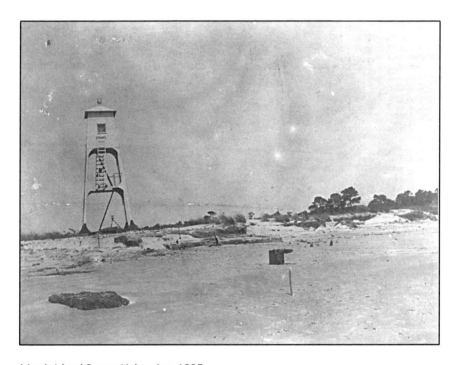

Morris Island Range Light, circa 1885.

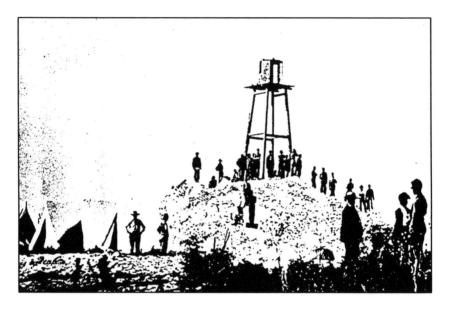

"Ruins of Old Charleston Lighthouse on Morris Island." This temporary light was installed during the Civil War by Federal troops during the summer of 1863.

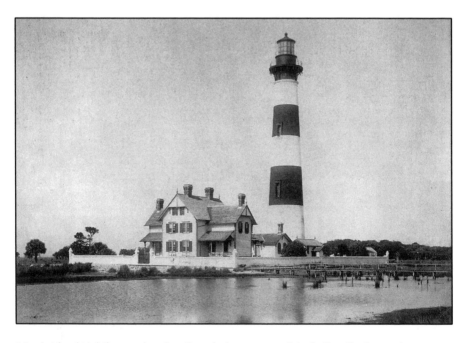

Morris Island Lighthouse showing the whole compound, including the keeper's house, equipment shed, and retaining wall, circa 1900.

Morris Island Range Light, no date.

There was a keeper and two assistants. They all lived in a three-story keeper's house with their families. Because they were on an island, they had to be self-sufficient. They had livestock and vegetable gardens. A teacher was brought to the island on Mondays and returned to the mainland on Fridays. She taught in a one-room schoolhouse. It was one of fifteen buildings on the island.

Many things have taken a toll on the lighthouse, including an 1885 hurricane (and many since that time), an 1886 earthquake, World War II bombing practice, and neglect. But the biggest problem for the lighthouse was island erosion. When jetties were built in 1889 to save Charleston Harbor, they caused huge erosion issues for the island. The tower began to lean because of structural damage and land loss due to erosion, reducing the light's range.

By 1938, the keeper's house and many other buildings had been moved (some reports say the house was destroyed the following year). Buildings were destroyed so that the tide wouldn't carry the debris out to sea. The lighthouse was automated that same year. The Fresnel lens was removed and sold at auction.

Over the years, the land around the lighthouse has been lost to erosion. In 1962, the lighthouse was deactivated and on track to be destroyed when Sullivan's Island Lighthouse was built. The Charleston Preservation Society was formed to prevent the lighthouse from being destroyed. They saved the beacon and raised funds to put an underground steel wall around the tower to prevent further erosion.

The nonprofit group Save the Light is now in charge of trying to save the light. They bought the lighthouse in 1999 and had it listed on

Original Charleston Light-house, circa 1767.

the National Register of Historic Places. Then they gave it to the state of South Carolina, after working out a lease agreement.

The group has been working with the Army Corps of Engineers and a private engineering consultant to determine how to proceed. In spring of 2010, new concrete piles were installed under the foundation. This will further stabilize the lighthouse.

Points of Interest

There is much to see and do in Charleston, including harbor cruises. Check with the Charleston tourism bureau for a complete list of options. There is a visitor center at 375 Meeting Street. 800-774-0006. www.charlestoncvb.com

Visitor Information

The lighthouse is not open to the public. Click on the "live video" link at www.savethelight.org or get a good look at the lighthouse from Folly Beach. Beware of sand fleas and mosquitoes.

Getting There

Take SC 171 to James Island and Folly Beach. Turn left onto Ashley Street at the last red light before the oceanfront Holiday Inn and follow this road until it dead-ends. There is a parking area on the right. Proceed on foot for about a half mile. The lighthouse can be seen about 300 yards offshore.

SULLIVAN'S ISLAND LIGHTHOUSE

Closest city: Sullivan's Island, Charleston County

FAST FACTS

- This was the last lighthouse built in South Carolina.

- It has an elevator and air conditioning.

- It has the potential to be one of the most powerful lights in the world.

There were at least two beacons here before the present one was built. Records indicate a small red light tower was built at the Charleston harbor entrance in 1848. It had a fixed white light, sixth-order Fresnel lens, and had a range of a little over ten miles. It was rebuilt in 1872, presumably damaged during the Civil War since it was positioned just 300 hundred yards southwest of Fort Moultrie.

Another lighthouse was built in 1888. It became the rear light and the other tower was the front light. The Sullivan's Island Range Lights were renamed the South Channel Range Lights during May 1899.

By 1962, the shifting of the channel marking Charleston harbor made it necessary to build a new lighthouse. It was positioned on the

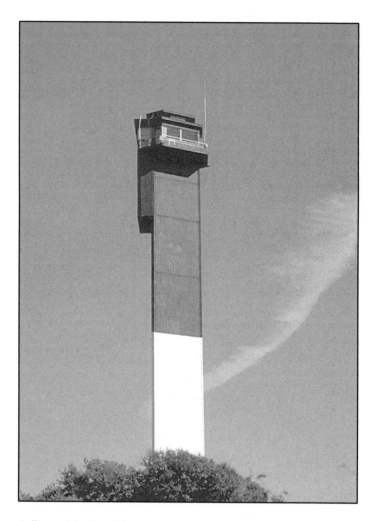

Sullivan's Island Lighthouse.

north side of the harbor. It was originally painted orange and white but was later changed to black and white.

Anchored by steel girders and a concrete foundation, the modern tower looks very different from older, more traditional lighthouses. It is three-sided and has aluminum paneling, giving the tower added protection against hurricanes.

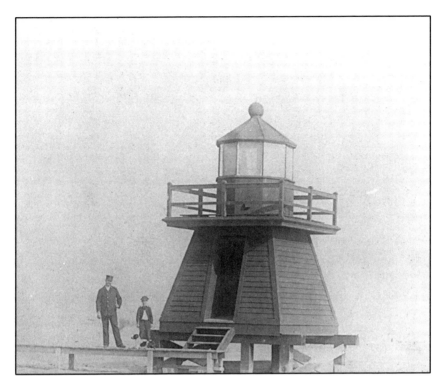

Sullivan's Island Range Light (possibly front light) with keeper and presumably his son and family dog, no date.

Modern amenities, such as an elevator and air-conditioning, have been installed at this lighthouse. The air-conditioning is required for the offices inside the tower. The elevator goes most of the way, but not all the way, to the top. There are stairs leading to the lantern room. The elevator was built because many accidents had occurred on the lighthouse steps, but the elevator is reported to be out of service fifty percent of the time. Employees find themselves using the stairs anyway.

When it was first illuminated on June 15, 1962, the lighting system was very different from what is now being used. With its 28,000,000-candlepower capability, Sullivan's Island Lighthouse was probably one of the most powerful lights in the world. However, the six-lamp lighting apparatus was more than was needed. And it was dangerous. Keepers had to

wear heat protective outfits to enter the lantern room. Due to complaints from neighbors, panels had to be placed over the windows to dim the blinding light. So, in 1967, it was reduced to 1,170,000-candlepower using only three low-intensity lamps. The DCB-24 lights have a range of twenty-six miles out to sea. It became automated in 1975. Since that time, the light shines day and night. One bulb blinks every five seconds, the second every twenty seconds, and the third every thirty seconds.

Upon seeing it for the first time, some have remarked that this lighthouse looks more like an air traffic control tower than a lighthouse. Interestingly, this strange-looking beacon is as important as an air traffic control tower. Charleston is one of the busiest ports in the U.S. The narrow shipping channel is a challenge. This lighthouse allows ship crews to determine exactly where the channel is so that they can safely reach the port. Last year, 1,539 ships and barges utilized Charleston and Georgetown ports. Charleston is considered to be one of the most efficient and productive ports in America.

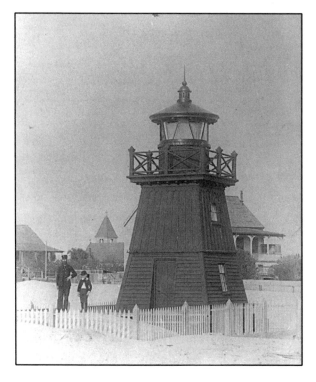

Sullivan's Island Range Light (possibly rear light). This looks like the same keeper and his son as in previous photo, no date.

Other Points of Interest

Fort Moultrie is on Sullivan's Island. It was used during the Revolutionary and Civil wars. It is part of Ft. Sumter National Monument. 843-883-3123. www.nps.gov/fosu

Patriots Point Naval Museum in Mt. Pleasant houses the largest naval and maritime collection and is home to aircraft carriers, Coast Guard cutters, submarines, and more. 866-831-1720. www.patriotspoint.org

Visitor Information

This lighthouse is not open to the public. It is part of the Coast Guard compound so visitors are not allowed. There is an old boathouse, a keeper's house, and a storage building from an 1889 lifesaving station on site. These structures are on the National Register of Historic Places. The

Former keeper's house, now used by Coast Guard personnel.

former keeper's house has been restored and is used for lighthouse personnel. The property has been transferred from the U.S. Coast Guard to the National Park Service, but the Coast Guard maintains the light.

Getting There
Take Highway 17 or SC 703 through Mt. Pleasant to Sullivan's Island. The lighthouse is easily seen near Fort Moultrie, from the left side behind a locked gate. Sullivan's Island is reached by drawbridge so there can be traffic delays during the summer months.

This is an example of a house designed to be hurricane proof, Sullivan's Island.

HUNTING ISLAND LIGHTHOUSE

Closest city: Beaufort, Beaufort County

FAST FACTS

- This is the only lighthouse in South Carolina that is open to the public.
- It was made of cast-iron plates so that it could be disassembled and put back together at another location if erosion became a problem.
- There is a small museum on site inside the former oil shed.

At one time, this lighthouse was very important for guiding ships from the busy harbors of Beaufort and Charleston to Savannah, Georgia. In 1859, two structures were required for the original Hunting Island Light Station.

The front beacon was a 95-foot conical tower built of brick with a brass lantern. The lantern housed a second-order Fresnel lens that revolved and flashed every thirty seconds. It could be seen seventeen miles out to sea. The rear beacon was designed as a thirty-two-foot-high tower made of wood and painted white. It had a fixed light housed inside a

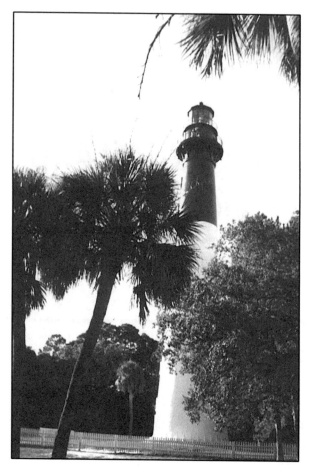

Hunting Island Lighthouse.

sixth-order Fresnel lens. Records do not show if this rear tower was ever built. Whatever did exist of the light station was destroyed during the Civil War.

The tower you see today was put into service in 1875. Built further inland from the original location, the tower is built of cast-iron plates. Each plate weighs 1,200 pounds. Cast-iron plates were chosen because the lighthouse can be dismantled and reassembled elsewhere if needed.

There were construction problems due to illness. Many of the crew contracted malaria, which is caused by mosquito bites.

This 136-foot-tall lighthouse cost $102,000, including its 100,000-candlepower beam. The lamp was lit by kerosene and reflected through a second-order Fresnel lens. The light flashed every thirty seconds and could be seen eighteen miles out to sea.

A keeper and two assistants were needed at this lighthouse, so a big, three-story keeper's house was built. The home had twelve rooms. An oil shed and two storage buildings were also erected.

Erosion became a serious problem by 1889. So, the tower was disassembled and transported a mile and a quarter to its new location. The plates have markings showing how to reassemble the lighthouse. The cost to relocate the tower was only about $50,000, which is much less than it would cost to build a new lighthouse. The other buildings were also moved that year.

Hunting Island Lighthouse was deactivated on June 16, 1933, replaced with a whistle buoy. The keeper's house was destroyed by fire a few years later. The Coast Guard used Hunting Island during World War II to protect our coastline and the Army Air Corps used the lighthouse as a radio station during part of the war. Military were stationed on the island.

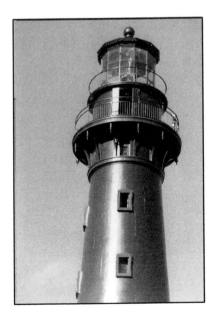

A decorative light was installed in 1994 so that mariners and visitors could see it shine. Today, the lighthouse is part of Hunting Island State Park. On average, fifteen feet of beach erodes from the island every year, the most of all South Carolina islands.

The island got its name because it was an abundant hunting ground. Keepers and their families always had plenty of food, including deer, wild

Close up of upper portion of Hunting Island Lighthouse.

Close up of lantern room prisms.

Lighthouse storage building.

NOTICE TO MARINERS. 300

(No. 17.)

COAST OF SOUTH CAROLINA.

ST. HELENA SOUND.

HUNTING ISLAND LIGHT STATION.
MAIN LIGHT REVOLVING, BEACON LIGHT FIXED.

Notice is hereby given that at sundown on Friday, the 1st day of July next, the new light-house and beacon on the north point of Hunting island, S. C., will be lighted, and will be kept burning during that night and every night thereafter from sunset to sunrise.

The main light-house is a conical tower built of reddish gray brick, the upper 25 feet of which will be colored white. The tower is surmounted by a brass lantern.

The illuminating apparatus is a lens of the second order of the system of Fresnel, showing a *revolving* light of the natural color, the interval between the flashes of which is 30 *seconds*. The tower is 95 feet high, and the focal plane is 108 feet above the level of the sea. The light should be visible in clear weather a distance of 17 nautical miles.

BEACON LIGHT.

The beacon light is on an open-work wooden frame, painted white, 32 feet high. The focal plane is 39 feet above the level of the sea. The illuminating apparatus is a lens of the sixth order of Fresnel; showing a *fixed* light of the natural color.

The direction of the range is N. 77° E. and S. 77° W. and the two lights and the outer buoy of the Slough or Northern channel are all in range. The bearings magnetic.

The position of the light as given by the Coast Survey is—

Latitude 32° 21′ 30′ N.
Longitude 80° 24′ 30′ W. of Greenwich.

The magnetic variation is 3° east.

After June 30 next the St. Helena bar light-vessel will be discontinued, and after she has been repaired she will be placed on Cambahee bank, St. Helena sound. Due notice of the time of placing her will be given.

By order of the Light-house Board :

W. H. C. WHITING,

Capt. Corps of Engrs., U. S. A.

SAVANNAH, GA.,
March 8, 1859.

Notice to mariners announcing Hunting Island Lighthouse, 1859.

turkeys, and waterfowl. They also planted gardens and raised chickens and hogs. Like many of the remote lighthouse locations, an extensive tramway had to be built from the water up to the lighthouse. This is how supplies and lighthouse lamp oil were transported.

Other Points of Interest

Beaufort, the nearby port city, is worth a visit. There are many historic buildings and homes, such as the Beaufort Arsenal, Verdeir House, the Beaufort Museum, and the Old Sheldon Church. Nearby are the Penn Center, the Lowcountry Estuarium, and St. Helena's Church. For more information, visit www.discoversouthcarolina.com and www.beaufortonline.com.

Visitor Information

This lighthouse is open to the public! This is the only lighthouse in South Carolina that is accessible to visitors. There is a fee to enter the park and a fee to tour the lighthouse. There are 167 steps to the top of the lighthouse where visitors are rewarded with a terrific view of Hunting Island State Park. Be sure to check before visiting as the stairwell is periodically closed for repairs and maintenance. The former oil shed serves as a mini-museum, relating the history of this lighthouse. 843-838-2011. www.huntingisland.com

Getting There

The lighthouse, at 2555 Sea Island Parkway, is sixteen miles south of Beaufort, in the Hunting Island State Park. Take Highway 17 to US 21 and follow signs to the state park.

Distance to Hunting Island from

Cincinnati, OH is 648 miles
Chicago, IL is 908 miles
Charlotte, NC is 238 miles

A Ghost at Hunting Island Light

A reader submitted this story to me because she thought I might find it interesting. With her permission, I have reprinted it here:

Back in the early 1990s, my husband's family went on a vacation and visited Hunting Island Lighthouse. Bill and his brother had brought two friends with them on the trip. The four guys climbed the stairs to the top of the lighthouse. Upon reaching the door at the top, they walked around the lighthouse enjoying the view. After about ten minutes, they decided to leave. The two friends started downstairs while the two brothers stood for another minute or two on the opposite side of the doorway. After several minutes, they walked around the walkway toward the door and were startled by a young black girl (about 4 or 5 years old) in a white Sunday school dress with pigtails and light pink bows in her hair. They were shocked that such a young child was alone. She said nothing, but raised her hand, as if to wave to them. She turned and went the other way. They went after her but she was gone. They went around the walkway in different directions and met each other on the other side. They quickly went to the doorway and looked down the winding stairs…no little girl, only their friends walking down the steps. They yelled down, asking if they had seen a little girl. Their friends yelled back, "No," laughing as they kept walking. The brothers quickly departed the lighthouse, unsettled by what had happened. To this day, my husband, Bill, believes he saw a ghost at the Hunting Island Lighthouse.

Brandi Chambers
Summerville, SC

Hunting Island is 5,000 acres of incredible marsh and beach. It is a great place for fishing, hiking, swimming, and camping. There are 200 campsites and fifteen cabins for rent. Due to popularity, you'll need to book well in advance. More than one million visitors come to this park every year. It is one of the most popular parks in South Carolina.

Hunting Island Beach

HILTON HEAD LIGHTHOUSE

Closest city: Beaufort, Beaufort County

FUN FACTS

- This lighthouse was also called Leamington Light.

- It now sits on the eighth hole of a golf course.

- It is one of the few skeletal towers still in existence. One look at it and you'll know why it's called a "skeletal" or "skeleton" light house.

A lighthouse was built during the Civil War in 1863. It was destroyed by a storm six years later. After the war, Congress approved a pair of lights to be built on Hilton Head. Due to a land dispute, it wasn't until 1881 that the lights were finally lit.

The front beacon was a thirty-five-foot tower atop a keeper's house. The rear beacon was a 94-foot tower. The beacons were roughly a mile and one-quarter away from each other. The front tower had a flashing light while the rear beacon had a fixed white light. The front lighthouse

First Hilton Head Light Tower, no date. This looks like it was a pretty remote location at that time.

was ultimately made mobile so that it could be moved as the channel shifted.

There was a second keeper's house, a boathouse, and several out-buildings. Only the lighthouses and the oil shed still exist. The front light was moved elsewhere on the island and is privately owned.

The rear beacon, known as the Rear Lighthouse of Hilton Head Range Light Station and the Leamington Light, is more commonly known as the Hilton Head Lighthouse. The tower is made of steel cast-iron while the lantern and watch rooms are made of cypress wood.

Six concrete foundation pilings, measuring thirty feet in diameter, anchor this massive structure. One piling was put in the middle of the tower to support the 112-step circular metal staircase, which goes all the way to the lantern room. The keeper had to carry kerosene from the oil shed out to the lighthouse and up the stairs to the lantern room several times a night.

A U.S. Marine corps was stationed just outside the lighthouse dur-ing World War II. Temporary barracks were built to house the men and

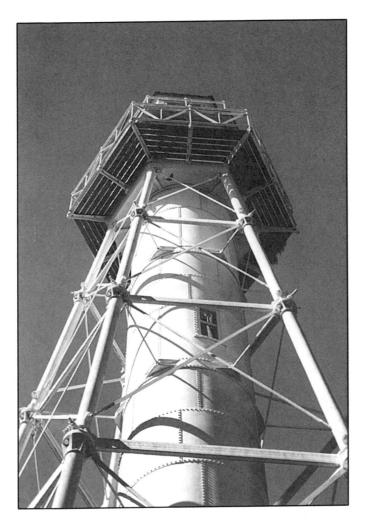

Close-up of the skeletal Hilton Head Lighthouse.

a road was created that led from the tower to the beach where patrols were conducted.

The lighting apparatus was removed when the lighthouse was taken out of service in 1932. Its present optic, sodium vapor (decorative), was installed in 1985. This is the only skeletal lighthouse still in existence in South Carolina and one of the few of its kind in the U.S.

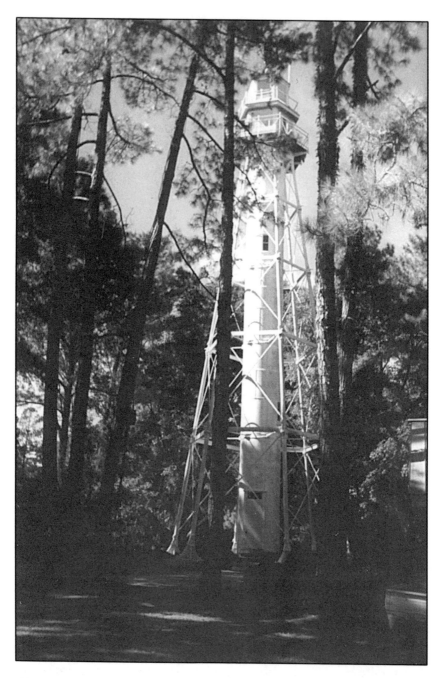

Hilton Head Lighthouse is now in the middle of a championship golf course.

Close-up of two of the six concrete foundations that anchor the tower. Each measures thirty feet in diameter.

Brick oil shed, only outbuilding still in existence.

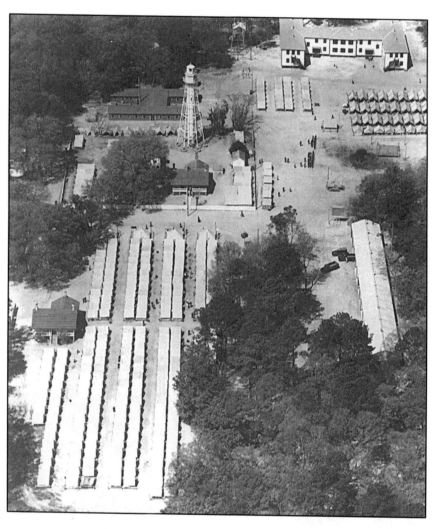

This area was used by U.S. Marine Corps to train defense battalions, 1940.

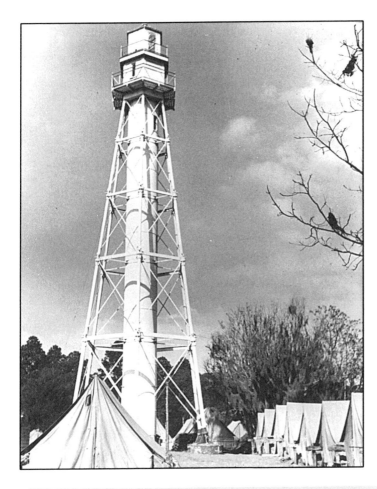

*U.S. Marine
Corps troops
camped at the
base of the
lighthouse,
1940.*

Want To Buy a Lighthouse?

Ever dreamed of owning a lighthouse? In recent years, the
Coast Guard has sold close to fifty old lighthouses. If no local
conservation group is interested, the Coast Guard sometimes
auctions them off to the highest bidder. Here's a partial list of
what has sold and for how much:

Bloody Point Bar (Maryland) $100,000

Fourteen Foot Bank (Delaware) $200,000

Goose Rocks Light (Maine) $27,000

Newport News Middle Ground (Virginia) $31,000

Sandy Point Shoal Light (Maryland) $250,000

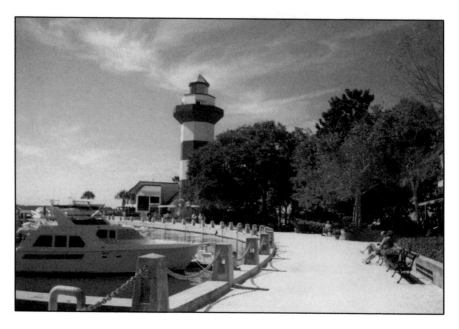

Harbour Town "Lighthouse."

Other Points of Interest

Harbour Town Lighthouse can be seen by visitors to Harbour Town marina. Construction was completed in 1970 on the ninety-foot beacon. It has a hexagonal shape to minimize maintenance and to protect it from the elements. Visitors can climb the 112 steps to the top for a great view at no cost. There is a gift shop at the top too. While it does serve as a navigational aid or at least as a daymarker, it is not considered to be a real lighthouse. It was built as a symbol for Sea Pines Plantation. Nonetheless, it does have a flashing light that can be seen by boaters up to fifteen miles away on a clear night. At the security gate to the island, visitors may purchase a day pass that permits them entry into Sea Pines, which has numerous shops and restaurants. Once at Sea Pines Plantation, take Glenwood Drive to Lighthouse Road and on to Harbour Town.

Coastal Discovery Museum offers visitors a glimpse into the island's rich history. The museum often offers tours on the area's wildlife, history, and more. 100 William Hilton Parkway, Hilton Head. 843-689-6767. www.coastaldiscovery.org

Visitor Information
This lighthouse is not open to the public. It sits on the Arthur Hills Golf Course at Palmetto Dunes Resort. The course is open only to members and their guests. The golf course was designed to incorporate the historic beacon, which is located at the eighth hole. Visitors must have a pass to enter the resort. The lighthouse cannot be seen from anywhere else due to the layout of the course and the large trees surrounding the lighthouse.

Getting There
Take US 278 to Hilton Head and follow the signs to Palmetto Dunes Resort.

Distance to Hilton Head Island from
Columbia, SC is 164 miles
New York City is 867 miles
Savannah, GA is 40 miles

HAIG POINT AND BLOODY POINT LIGHTHOUSES

Closest city: Hilton Head, Beaufort County

FAST FACTS

- There were two sets of identical lighthouses on Daufuskie Island.

- Bloody Point, which is at the southern tip of the island, got its name after a bloody battle during the Yemassee Indian War.

- A man fell to his death from the Haig Point Lighthouse and the Bloody Point Lighthouse was reportedly haunted by a former lighthouse keeper.

In 1872, the U.S. government bought five acres on Daufuskie Island for $745 and approved $15,000 to build two sets of range lights on the land. The following year, a pair of lights at Haig Point and another pair at Bloody Point were built. These lights were critical for helping ships on their way to Savannah and Charleston through Calibogue Sound and the Intracoastal Waterway.

The two Haig Point range lights were positioned one-half mile from each other. The rear light was a wooden tower built atop a keeper's house, seventy feet above sea level. A fifth-order Fresnel lens housed a

Haig Point range lights were named after wealthy plantation owner George Haig. Bloody Point was named after two massacres, known as the Yemasee Indian War of 1715, which took place where the lights were later built.

fixed white light that was fueled by lamp oil. A fence was built around the house in 1879 to keep out island cattle.

The front range light was made of wood and housed a steamer lens (originally made for a steam engine locomotive) rather than a Fresnel lens. It was seventeen feet above sea level. This beacon was mobile so that it could move as the channel shifted. The lights had to line up properly to work. It was deactivated in 1924.

The next year, the Haig Point Lighthouse (rear light) and surrounding land was sold to M.V. Haas for $1,500. He turned the property into a hunting retreat. Elaborate parties were held until a drunken guest climbed to the top of the lighthouse one night and accidentally plummeted to his death.

Over time, the property fell into a state of disrepair. When the International Paper Corporation bought the land in 1984, the company began serious repair efforts using historical drawings to keep the renovations as accurate as possible. The renovations were completed in two years, including decorating the house with furniture from the same period. The lantern room can still be accessed using a series of stairs and ladders. The cistern and oil shed were also preserved.

The former Haig Point Lighthouse is now used as guest quarters for the company. It is still lit using a 247-candlepower beam encased in a large acrylic optic lens powered by a solar battery. The flashing light can be seen a little over nine miles away.

On the southeastern end of Daufuskie were the two Bloody Point range lights, which were identical to those at Haig Point. They were in operation until 1922. The tower was removed from the house and the lights and land were sold at auction. The house was the Daufuskie Island Inn for a while. Like Haig Point, Bloody Point had several owners and fell into poor condition over time.

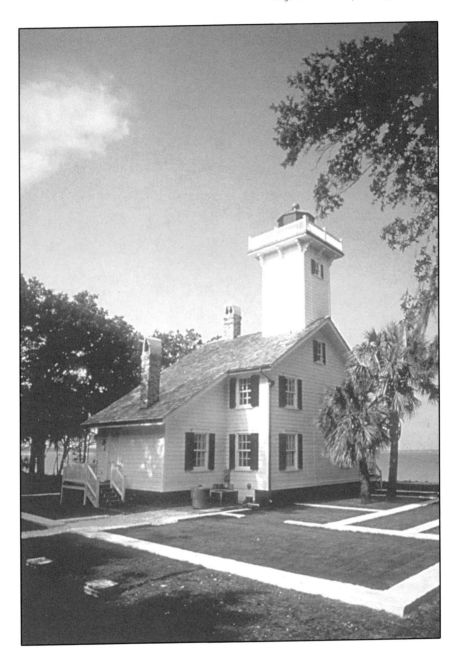

Haig Point Lighthouse.

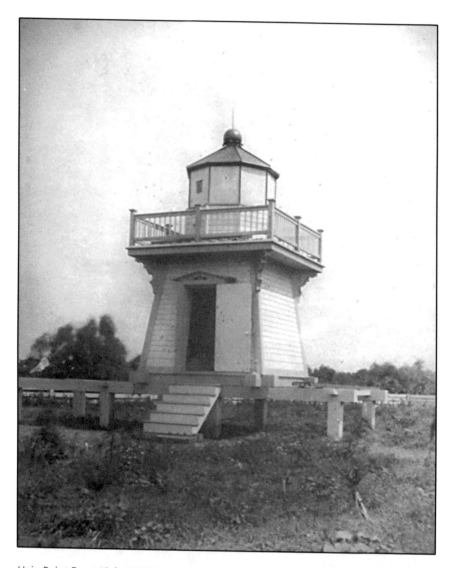

Haig Point Front Light, 1885. It was located a half mile from Rear Beacon and moved by oxen whenever the channel shifted.

Melrose Corporation bought the land and did some real restoration. They did not adhere to historical requirements, for example, a bathroom was added, the downstairs was made into one large room, and a new staircase was built. It became a pro shop for the Daufuskie Golf Club. The lighthouse was recently sold to a private owner when a new pro shop was built.

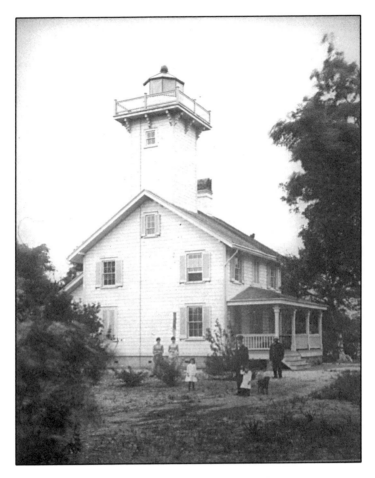

Haig Point Rear Light and keeper's family including their dog, 1885.

The last keeper of Bloody Point Lighthouse was Arthur A. "Papy" Burns. He bought the lighthouse when it was decommissioned because he loved living there. He was a colorful character. He never drank but he started the Silver Dew Winery behind the lighthouse. He moved off island in 1966 when his health began to fail. When he died in 1968, his body was returned to the place he loved so dearly. The old lighthouse is reportedly haunted by the spirit of Papy, who may not have left his old home after all.

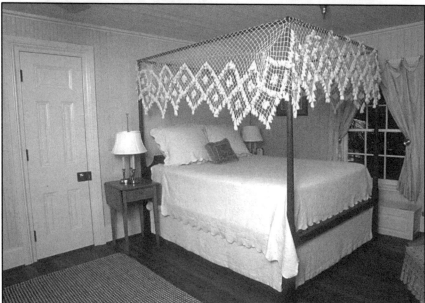

Interior photos of Haig Point Lighthouse.

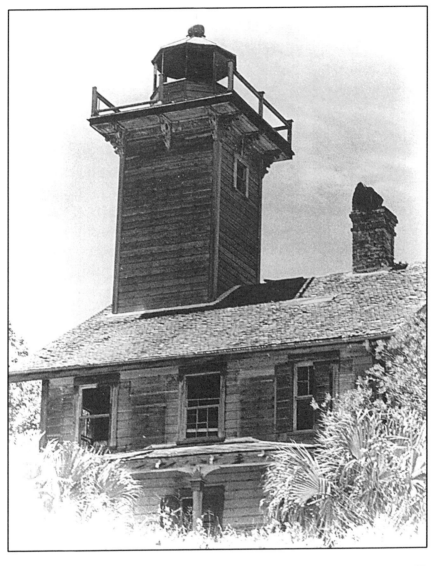

Haig Point Lighthouse before restoration, as shown in a Savannah newspaper, 1963.

About Daufuskie

This island of 5,000 acres is 2.5 miles wide and 5 miles long. Unlike the barrier islands of Hilton Head and Tybee, Daufuskie is a sea island. The population is 300–400. The island is divided into five parts: Haig Point Club, Daufuskie Island Club Resort, Oak Ridge, Bloody Point, and a large tract of unincorporated land with everything from mobile homes to mansions. The oldest buildings on Daufuskie are the First Union African Baptist Church and the Haig Point and Bloody Point lighthouses. The island didn't get electricity until 1953. Telephone service reached the island in 1973.

Author Pat Conroy taught school on the island before writing his best-selling book, *The Water is Wide*. A new school, Daufuskie Island School, was built in 1997 for grades K–5. Grades 6–12 attend school in Hilton Head. They are transported by a county school ferry.

In 1878, the toll was fifty cents for a round-trip ferry ride from Daufuskie Island to Savannah. Today, the fare starts at $26 per person but can cost much more if you have luggage, bicycles, or coolers.

Other Points of Interest

Savannah and Tybee Island Lighthouse and Museum. The lighthouse and keeper's house are open to the public. Visitors can climb the 178 stairs to the top during a self-guided tour and there is a gift shop. Groups can arrange After Hours Tours of the lighthouse by reservations only. Tybee Island, Georgia. 912-786-5801or 921-786-6538. www.tybeelighthouse.org

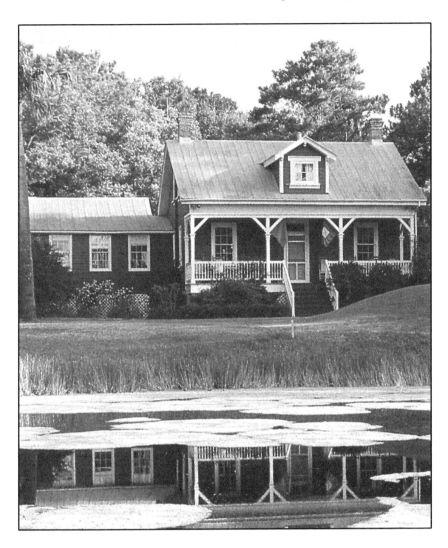

Bloody Point Lighthouse.

The First Union African Baptist Church is the oldest building on Daufuskie Island.

Visitor Information

Neither lighthouse is open or accessible to the public. Both are privately owned and visitors are not permitted on the property. There is a private ferry to the island. You cannot get on it unless you are a homeowner or resort guest. However, the former lighthouse can be seen from Harbour Town on Hilton Head Island or by boat in Calibogue Sound.

ADDITIONAL INFORMATION

Nonprofit Lighthouse Preservation Groups

<u>Local Groups</u>
Edenton Historical Commission (Roanoke River Lighthouse)
505 South Broad Street
Edenton, NC 27932
252-482-7800
www.edentonhistoricalcommission.org

Friends of Hunting Island (Hunting Island Lighthouse)
P.O. Box 844
St. Helena Island, SC 29920
843-838-7437
www.friends-of-hunting-island-sc.org/lighthouse.html

Friends of Oak Island Lighthouse (Oak Island Lighthouse)
1100 Caswell Beach Road
Caswell Beach, NC 28465
www.oakislandlighthouse.org

Ocracoke Preservation Society (Ocracoke Lighthouse)
P.O. Box 1240
Ocracoke, NC 27960
252-928-7375
www.ocracokepreservationsociety.org

Old Baldy Foundation (Bald Head Island Lighthouse)
P.O. Box 3007
Bald Head Island, NC 28461
910-457-7481
www.oldbaldy.org

Outer Banks Conservationists (Currituck Lighthouse)
1101 Corolla Village Road
Corolla, NC 27927
252-453-8152
www.currituckbeachlight.com

Outer Banks Lighthouse Society (OB Lighthouses)
P. O. Box 2141
Winterville, NC 28590
www.outerbankslighthousesociety.org

Save the Light (Morris Island Lighthouse)
P. O. Box 12490
Charleston, SC 29422
843-633-0099
www.savethelight.org

Staying in a Lighthouse

Some private owners and nonprofit groups rent rooms in their lighthouses to raise money for maintenance. For example, The Point No Point Lighthouse on Puget Sound (one hour from Seattle) allows visitors. Lodging includes living room, dining room with breakfast nook, full kitchen, two bedrooms, and a bathroom. For more information, contact the U.S. Lighthouse Society at 415-362-7255 or www.uslhs.org.

National Groups

The Lighthouse Preservation Society

11 Seabourne Drive
Dover, NH 03820
www.lighthousepreservation.org

United States Lighthouse Society

9005 Point No Point Rd. NE
Hansville, WA 98340
415-362-7255
www.uslhs.org

Tourism Resources

www.outerbanks.org/attractions/lighthouses
www.visitnc.com
www.discoversouthcarolina.com

Lifesaving Stations

Here is a record of Outer Banks lifesaving stations. Unless otherwise noted, they are private residences or no longer exist.

Wash Wood (1878–1933)

Penneys Hill (1878)

Currituck Beach (1874–1904)

Poyners Hill (1878, 1904–08)

Caffeys Inlet (1874–1899) Now the Sanderling Restaurant

Paul Gamiel Hill (1878, 1909 new site)

Kitty Hawk (1874–1915)

Kill Devil Hills (1878–1930s)

Nags Head (1874–1912)

Bodie Island (1878–1923) Used by NPS

Oregon Inlet (1874–1897)

Pea Island (1878–1881) See below

New Inlet (1882)

Chicamacomico (1874–1911) See below

Gull Shoal (1878)

Little Kinnakeet (1874–1904) Used by NPS

Big Kinnakeet (1878–1929)

Cape Hatteras (1882) Replaced by Coast Guard station in 1935

Creeds Hill (1878–1918)

Durants (1878) Being restored for commercial use

Hatteras Inlet (1883)

Ocracoke (1905–early 1940s) Near Coast Guard Station at Ocracoke Village

Portsmouth (1894) Maintained by National Park Service as part of historic Portsmouth Village on abandoned Portsmouth Island

OPEN TO THE PUBLIC

Chicamacomico Lifesaving Station, established in 1874, was among the first of many placed along the Outer Banks. The crew saved many lives over the years but one of the most heroic happened in 1918 when an English tanker, *Mirlo*, caught fire after being torpedoed by the Germans. Forty-two sailors were saved by the crew of Chicamacomico. The name of this community was later changed to Rodanthe, but the lifesaving station name remained the same.

This station and outbuildings are considered to be one of the most complete U.S Lifesaving Service/Coast Guard Station complexes on the Atlantic Coast. Visitors will find an impressive collection of artifacts, photographs, uniforms, documents, and displays (see page 61). There are programs offered during the summer months, including reenactments and special events. NC 12 in Rodanthe. 252-987-1552. www.chicamacomico.net

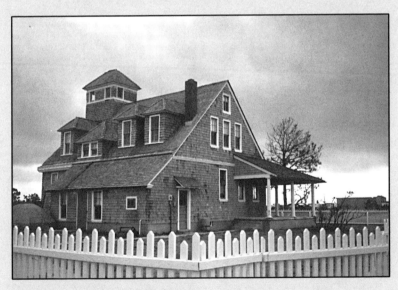

Chicamacomico Lifesaving Station.

Pea Island Lifesaving Station was the first station manned by an all-black crew and at one time the only all-black crew in the U.S. It was in operation from 1880 until 1947. During that time, 60 men served here and saved at least 200 lives.

Captain Richard Etheridge was the first African-American to command a lifesaving station. He took his job seriously, putting his men through grueling lifesaving drills. This training came in handy when they had to make especially difficult rescues, such as in October 1896. They had to save the men aboard *E.S. Newman*. The vessel was blown one hundred miles off course by a severe storm. The surf men braved the treacherous waters not once but ten times in order to save all that were onboard. The crew received Gold Lifesaving Medals for their efforts.

The old cookhouse that was once part of the lifesaving station has been restored and is part of the Pea Island African American Heritage Center at Manteo, NC.

LIGHTHOUSE TERMS

Aerobeacon: modern light used in many lighthouses.

Argand lamp: hollow wick oil lamp.

Automated: when a light no longer has to be manually turned on and off but is controlled by a computer or timer system.

Candlepower: the measurement of how strong a light is, how far away it can be seen. One candlepower equals the light of one candle.

Cape: a piece of land that extends out into the water. If boats and ships don't know where a cape is, they might hit it. We have many capes in the Carolinas, such as Cape Hatteras (NC) and Cape Romain (SC).

Channel: the bed of a stream or river. It is the deep part of a river or harbor.

Daymark: color of paint and pattern on a lighthouse that makes it easy to tell which lighthouse it is during the day.

Erosion: when water carries sand away from the beach or an island. This can cause the island or beach to erode or disappear over time.

Fixed light: steady, nonflashing beam.

Focal plane: the height measure of a lighthouse from sea level to the lighthouse's beam of light.

Fog signal: a whistle, bell, horn, or siren that is sounded when there is heavy fog so ships won't run aground on a shoal.

Fresnel lens: prisms (glass pieces) that have been cut and fitted around the lamp bulb. Hundreds of prisms are needed to cover the bulb. Because of the design, the light from the lamp bulb refracts as it passes through these prisms in such a way as to produce a single strong beam of light.

Gallery: the platform, walkway or balcony found outside the watch room and lantern room. Keepers used the gallery to clean the outside windows of the lantern room.

Inlet: a narrow waterway that leads inland from the ocean. A stream or a bay is an inlet. They are usually narrow passages of water between two islands. Boats or ships need a lighthouse to show them the way in the dark.

Keeper: the person responsible for the lighthouse; the main duty was to light the lighthouse every night and put out the light every morning, but there are many other duties.

Lamp: lighting system inside a lens.

Lantern room: the glass-enclosed room found at the top of the lighthouse that holds the lighting system.

Lens: curved piece of glass placed around the light to focus and concentrate it.

Lightship: A lightship is basically a lighthouse on a ship. These were used in places where lighthouses could not or should not be built.

Log: a journal in which keepers recorded daily activities and how much fuel was used.

Parabolic: metal bowl-like piece (reflector) with a lamp inside the middle of this reflector.

Prism: specially cut piece of glass that reflects or refracts light.

Range lights: two light towers that were used to mark the entrance to an inlet or channel. One light was moveable so that it could always line up with the light on the other side of the waterway. The channel or inlet might shift so the light had to shift too. This showed ships or boats exactly what route to take.

Reflect: to throw or bend back light from a surface.

Refract: to deflect or bend light from a surface.

Revolving light: flashing light; with a Fresnel lens, the light doesn't revolve to make it flash but the lens revolves to create a flashing light. An aerobeacon is a flashing light that works differently from a Fresnel lens. Each lighthouse has a different pattern of flashing light to make the light identifiable at night. If you see a certain flashing pattern you can recognize it as being a certain lighthouse, thereby knowing exactly where you are.

Shoal: a sandy elevation in shallow water caused by waves or currents.

Spider lamp: shallow brass pan filled with oil and several wicks. The wicks are lit just like a candle is lit.

Watch room: room below the lantern room where the keeper stored fuel and stood watch. The lantern room is too crowded with lighting equipment to stay in for any period of time—and too hot.

Wick hollow: concentric cotton wick used in Argand lamps (and some other lamps).

"Wickie": nickname given to lighthouse keepers because they spent so much time cleaning and trimming the lamp wicks.

LIGHTHOUSE QUIZ

1. Which lighthouse has a black and white horizontal strip pattern?

2. Which lighthouse is painted all white?

3. Which lighthouse has a plaster-over-brick exterior?

4. Which Outer Banks lighthouse was left unpainted?

5. During colonial times, ships had to pay a flat fee or toll when the ship passed a lighthouse on its way into port. True or false?

6. In 1889, American lighthouses came under the control of the U.S. government. True or false?

7. When was the Fresnel lens discovered?
 1802
 1822
 1790
 1890

8. What is the name given to people who study lighthouses?
 Wickies
 Pharologist
 Fresnelist
 Lightologists

9. If there is fog, a sound will be made to warn ships. Which of the following does not belong?
 Siren
 Bell
 Fog horn
 Yelling or shouting

10. What is the most common material used in lighthouse construction?

11. Which state has more lighthouses than any other state?

12. The first keeper made $250 a year. True or false?

13. The most powerful lighting system found in a lighthouse can be seen how many miles out to sea?
 9
 19
 25
 50

14. What were some of the things used to fuel the lights? Choose all that apply.
 Whale oil
 Wild cabbages
 Manure
 Electricity

15. How many keepers could a station have?
> 1
> 2
> 3
> 5

16. How many lighthouses still have keepers?
> 1
> 10
> 25
> 50 or more

17. What is the tallest lighthouse in America?

18. What is a floating lighthouse called?
> Lightship
> Lighthouse tender
> Floating lighthouse
> Caisson lighthouse

19. What is the earliest lighthouse known to have been built?

20. Which was the last lighthouse built in America?

Answers:

(1) Bodie Island Lighthouse (2) Ocracoke Island (3) Old Baldy (4) Currituck 5) False. The toll was dependent on the weight of the cargo. (6) False. The government assumed responsibility in 1789 when the Lighthouse Board was established. (7) 1822 (8) Pharologist (9) Yelling or shouting (10) Brick (11) Michigan (more than 120) (12) True. George Worthylake made $250, which would be about $16,000 in today's dollars. (13) 25 (14) Whale oil, wild cabbages, and electricity (15) A station could have up to five keepers (16) 1 (17) Cape Hatteras (18) Lightships. They were placed where lighthouses couldn't be built. (19) Pharos of Alexandria (20) Sullivan's Island, SC

IMAGE CREDITS

Dare County Tourist Bureau pages 69, 78

Georgetown Chamber of Commerce pages 115, **CP4** (top)

International Paper Realty Corp. pages 159, 162, **CP4** (bottom)

Marine Corps Recruit Depot/Eastern Recruiting Region, Parris Island pages 152, 153

Martin Coble page 61 (top)

Melrose Corp. page 165

National Archives pages 28 (bottom), 64, 90, 104, 105 (top), 114, 116, 121, 122, 123, 129, 130 (bottom), 131, 135, 136, 148, 160, 161

National Park Service, page 143

NC Division of Tourism, Film Development pages 17, 26, 31 (top), 33, 38, 42, 43, 56 (top), 63, 64, 68, 73, 75, 76, 80, 87, 93 (bottom) 103, 128, **CP1–3**, **CP5–6**, **CP11** (bottom), **CP12** (bottom)

NC State Archives pages 28 (top), 31 (bottom), 40, 56 (bottom), 57, 58, 60 (top), 61 (bottom), 62, 70, 71 (top), 74, 77, 82, 83, 88, 89, 93 (top), 98, 99, 105 (bottom), 106, 108, 109 (top)

Outer Banks Conservationists

 Bill Parker page 29 (top)

 Bob Allen page 29 (bottom)

 Debra Johnston page 35

Outer Banks History Center and National Park Service page 39, 59, 60 (bottom), 71 (bottom)

Paper Realty Corp. page 163

Pictorial Histories Publishing Company pages 130 (top), 132 (*To Take Charleston The Civil War on Folly Island*, by James W. Hagy, 1993.)

Sarah McNeil page 91

Southport Maritime Museum page 102

Terrance Zepke pages 50, 86, 92, 109 (bottom right, bottom left), 120, 134, 137, 138, 140, 141, 142, 146, 149, 150, 151, 154, 166, 171, **CP7–CP10, CP11** (top), **CP12** (top)

INDEX

Here are some other books from Pineapple Press on related topics. For a complete catalog, visit our website at www.pineapplepress.com. Or write to Pineapple Press, P.O. Box 3889, Sarasota, Florida 34230-3889, or call (800) 746-3275.

Visit www.terrancezepke.com for more on ghosts, pirates, coastal history, and travel.

More Carolina books by Terrance Zepke:

Coastal North Carolina. This guide to the Outer Banks and the upper and lower coasts brings you the history and heritage of these fascinating communities. (pb)

Coastal South Carolina. Explore the history and charm of South Carolina's Lowcountry from Myrtle Beach to Beaufort. (pb)

Pirates of the Carolinas, 2nd ed. A collection of stories featuring thirteen of the most intriguing buccaneers in the history of piracy, all connected somehow to the Carolinas. (pb)

Ghosts of the Carolina Coasts. 32 ghost stories taken from real-life occurrences and from Carolina Lowcountry lore. (pb)

Ghosts and Legends of the Carolina Coasts. This collection of 28 stories ranges from hair-raising tales of horror to fascinating legends from the folklore of North and South Carolina. (pb)

Lighthouses of the Carolinas for Kids. The history of and facts about lighthouses along the Carolina coasts. Includes color photos and illustrations, ghost stories, and a quiz. Ages 9 and up. (pb)

More books about lighthouses:

Bansemer's Book of Florida Lighthouses by Roger Bansemer. This beautiful book depicts Florida's 30 lighthouses in over 200 paintings and sketches. (hb)

Georgia's Lighthouses and Historic Coastal Sites by Kevin M. McCarthy with paintings by William L. Trotter. Traces the history of 30 sites in the Peach State. (pb)

Florida Lighthouse Trail edited by Thomas Taylor. A collection of the histories of Florida's light stations by different authors, each an authority on a particular lighthouse. (pb)

Lighthouses of the Florida Keys, by Love Dean. A history of the Keys lights, from their construction to the politics that have swirled around them. (hb)

Guardians of the Lights, Revised Edition, by Elinor DeWire. Stories of the heroism and fortitude of the men and women of the U.S. Lighthouse Service. (hb, pb)

The Lightkeepers' Menagerie by Elinor DeWire. The story of the cold-nosed, whiskered, wooly, hoofed, horned, feathered, and finned creatures who have lived at lighthouses. (hb, pb)

Florida Lighthouses for Kids by Elinor DeWire. Learn about the people who designed and built Florida's lighthouses, meet some of the keepers, see how lighthouses operate. Ages 9 and up. (pb)

Lighthouses of Ireland, by Kevin M. McCarthy with paintings by William L. Trotter. The stories of the lighthouses that dot the Irish coastline. (hb)

Lighthouses of Greece, by Elinore DeWire and Delores Pregioudakis. This lavishly illustrated and carefully researched book covers more than 100 lighthouses, most still guiding ships around the Greek Island. (hb)